S0-BVA-965

Steel
Butterflies

HIGHLINE COLLEGE LIBRARY
WITHDRAWN
Highline College Library

Steel Butterflies

JAPANESE WOMEN
AND THE AMERICAN EXPERIENCE

NANCY BROWN DIGGS

STATE UNIVERSITY OF NEW YORK PRESS

Published by
State University of New York Press, Albany

© 1998 State University of New York

All rights reserved

Printed in the United States of America

No part of this book may be used or reproduced in any manner whatsoever without written permission. No part of this book may be stored in a retrieval system or transmitted in any form or by any means including electronic, electrostatic, magnetic tape, mechanical, photocopying, recording, or otherwise without the prior permission in writing of the publisher.

For information, address State University of New York Press, State University Plaza, Albany, N.Y., 12246

Production by Diane Ganeles
Marketing by Nancy Farrell

Library of Congress Cataloging-in-Publication Data

Diggs, Nancy Brown.
 Steel butterflies : Japanese women and the American experience / Nancy Brown Diggs.
 p. cm.
 Includes bibliographical references and index.
 ISBN 0–7914–3623–3 (hard : alk. paper). —
ISBN 0–7914–3624–1 (pbk. : alk. paper)
 1. Japanese American women—Social conditions.
 2. Women—Japan—Social conditions. 3. Sex role—United States. 4. Sex role—Japan. I. Title.
 E184.J3D52 1998
 305.42′0952—dc21 97–11077
 CIP

10 9 8 7 6 5 4 3 2 1

Contents

Acknowledgments vii

Introduction 1

Part I. Strangers in a Strange Land 7

1. The First Japanese in America 9
2. Problems of Today's Sojourners 17

Part II. Women in Japan: The Private Sphere 29

3. Household Managers 31
4. Wives 41
5. Mothers 49
6. Metamorphoses 59
7. Looking Back 63

Part III. Women in Japan: The Public Sphere 69

8. An Overview 71
9. The Young Single Woman 77

10. The Working Mother 79

11. The Career Woman 83

12. Modern Times 95

Part IV. The American Experience 109

13. Profiles 111

14. Living Conditions 115

15. Choices, Restrictions 121

16. Education 131

17. American Women 137

18. Connections 145

Summing Up 151

Appendix A 157

Appendix B 161

Notes 165

References 179

Index 199

Acknowledgments

First I would like to express my appreciation to all of the women, both Japanese and American, who made their experiences here come alive for me. Thanks to those in Japan, too: Dr. Robert Mockrish, Kumiko Muramoto, Dr. Noriaki and Yumiko Yoshikai, Kazuko Kamogawa and her family, and to those at the Takahashi Educational Institution, including Dr. Elenore Koch and Dr. and Mrs. Shōtaro Hamura.

My heartfelt gratitude to Drs. Ira Fritz, Robert McAndrews, Jeanne Ballantine, Kenji Oshiro, Harriet Leland, and Tanya Higgins. Their expert advice and encouragement were invaluable.

Special thanks, too, to my husband Matt, who has made so many adventures possible.

Finally, this book would not have been possible without the help of Reiko Lee. I owe her a great debt for all of her knowledge, insight, and assistance.

Introduction

> Delicate and fragile as blown glass, in stature, in bearing she resembles some figure in a painted screen, but as, from her background of glossy lacquer, with a sudden movement, she frees herself, like a butterfly she flutters. . . .
>
> —Giacomo Puccini, *Madama Butterfly*

Cornfields surround the suburban development where Masako Takita lives.[1] The wind rattling the cornstalks has a dusty feel, and there are cracks in the hard earth of still vacant lots. The sun is blazing on the Indiana prairie, but Masako and I meet in air-conditioned comfort. Dressed in a blue polo shirt and orange shorts, barefoot and wearing no makeup, she seems relaxed and at home in this large split-level. The house may look typically American, but a Buddhist altar stands in a place of honor, and the wide-screen television is showing a Japanese video when I walk in.

The first word that comes to mind when I think of Masako is "energy." As she talks she moves back and forth in her chair and gesticulates in the air to make her point. In her late forties, she has an animated face, a generous mouth, and a surprisingly deep, almost man-

nish voice. As we discuss differences between Japan and America, she speaks frankly about why she thinks the American divorce rate is so high, and why Japan is a safe country and the United States is not. She doesn't hesitate to suggest that in some ways we Americans could learn from Japan.

No one would ever mistake Masako Takita for Madame Butterfly.

Nor would Lieutenant Pinkerton find many women in today's Japan who resemble Cho-Cho San of the opera. And yet the image of the kimono-clad wife, delicate, obedient, and doll-like, is the one many Americans still hold of the typical Japanese woman.

This stereotype is no longer true, if it ever was. Superficial impressions can be misleading. In many ways Japanese women possess a strength that belies their demure appearance. What I learned from Japanese women living in America validates this strength of the Japanese woman, which more than matches that of her American counterpart.

There are striking differences in the way we look at life, but as I dug deeper, I was surprised at how much we have in common. We both face similar challenges and aspire to many of the same goals.

Education, ethics, the freedom—as well as the problems—of living in the United States, why Japanese women both envy and feel sorry for American women, what the future holds for Japanese women. These were a few of the topics covered in our far-ranging conversations.

How Japanese women see themselves and how they see us is what this book is all about.

What are their lives like, these women who have, mostly through no choice of their own, left home and family to settle in America for varying periods of time? How are they like us American women, and how do they differ?

Living in another country offers the opportunity to view one's native land from a different perspective. Getting away from the culture we've grown up with, the one

we consider "normal," gives us a basis for comparison that stay-at-homes never get.

Mariko Yoshino, for one, thinks that

> living far away from where I grew up, I had a chance to look at Japan as a third person. If you are in a society, you can't really observe what it's like, where you live, but here you have a chance to observe Japanese culture, the Japanese society. . . . That was one of the good things that happened to me.

Shizuko Kojima, another Japanese wife here for an extended period, agrees that after her stay here "I can think about Japan or Japanese people much more deeply," and more objectively.

It is possible in America to live a life-style not very different from that in Japan. You can eat in Japanese restaurants, buy Japanese groceries, see only Japanese friends, have your daily newspaper—in Japanese—delivered to your door, and even, in some areas, get Japanese television. Those who do this, as one woman put it, "just pretend they're in Tokyo," albeit a greener, more spacious and cheaper Tokyo.

However, since those who choose this life-style are not in a position to offer the insights I was seeking, I concentrated on interviewing Japanese women whose English was good enough that they were able to participate in American life.

Most of the women who shared their experiences were the wives of businessmen whose companies had transferred them to the Midwest, although a few were either students or the wives of students. I was fortunate to be in an area with many Japanese residents—there are some 20,000 Japanese in the Midwest and over 250 Japanese firms in Ohio alone—and yet in a region without self-contained Japanese communities. Japanese sojourners were therefore more likely to experience American culture.

It was a distinct advantage to be a foreigner, since Japanese will often open up more to a non-Japanese

than to their own compatriots. We live outside of the hierarchical structure that governs so much of Japanese life. Jill Sakai, an American whose husband is Japanese, has noticed, too, that her Japanese friends are much more outspoken in English, when they are freed from the restraints imposed by honorific language.

I spoke with several Americans who had lived in Japan for an extended period of time, including two American women married to Japanese men. In order to keep current on women's issues in Japan, I met with a number of people there, including a law professor who specializes in domestic relations, and several career women and housewives.

On a typical interview I would arrive at the participant's home, most likely a new ranch-style house in the suburbs, remove my shoes at the door, and be seated near my hostess on a comfortable, Western sofa. A few souvenirs of Japan would be displayed, perhaps a Japanese doll, a *koto*, or a Japanese wall hanging or flower arrangement. I always brought a small gift, something like a box of candy. Fortunately I love green tea, for I must have consumed gallons, and, if I was lucky, I'd also be offered a Japanese sweet.

I had developed a questionnaire to use as a starting point but did not strictly adhere to it, since the responses often led in new directions.

After explaining the project I usually began by asking how long the family had been in the States, why they were here, and if they had any children. To get the conversation rolling, I would ask what a typical day here would be like, compared to in Japan. This would lead into a discussion of how life in general is different and what advantages and disadvantages there are to living in America. I especially wondered how they felt American women were different from their Japanese counterparts and what similarities they had observed.

Questions covered family life, women's responsibilities in the home, community involvement both here and in Japan, aspects of Japanese culture they tried to keep

alive in America, and their children's experiences. I asked about problems in the family, including concerns about returning home, and if they felt the sojourn had affected them. Did they consider their stay "satisfactory"?

The next part of the questionnaire, which I thought of as the "happiness" section, asked: "What are the three best things that have resulted from your stay here?" "What gives you the greatest personal satisfaction in life?" and "What are the three things you miss most about Japan?"

There was a section on the interviewee's background in Japan, as well as a number of questions about Japanese society. These dealt with work attitudes and how they affect Japanese life, education and its importance, and changes in attitudes toward women working.

Two questions generally led the respondents to express some strong opinions: "What is your understanding of the role of a wife and mother today?" and "Why do you think the Japanese rate of divorce is so much lower than that of the United States?"

Although the interview rituals were all similar, it was surprising how my hosts' personalities differed. No matter whether they were shy or outspoken, calm or nervously energetic, stiffly formal or casually relaxed, all seemed eager to give me their impressions of America and how it differed from their homeland. No one I contacted hesitated to meet with me. Some limited their observations to the superficially obvious, while some looked for deeper differences, pondering the reasons for the differences.

Living in America can be a pleasant experience, they agreed, but life in a foreign country is not without its challenges, as we'll see later. Now, though, let's look at the first Japanese to come to America, those forerunners of today's sojourners who gave us our first impressions of Japanese people.

I

Strangers in a Strange Land

1

The First Japanese in America

By no means did I feel pleasant with the way those Californians treated me. It is a world-known fact that they hate Japanese. While I have been there four years I never went out to the parks, for I was so frightened of those savage people, who threw stones and bricks at me. . . . And I was spat on more occasionally.

—Yoshio Markino, 1897

Earlier Japanese residents faced much greater problems, of course, than those of today. Most early newcomers planned to return to Japan, but many never made the homeward journey.

Until the Meiji government opened Japan to the outside world in the 1860s, Japanese were forbidden to leave the country. One did get here before then, though. In 1841 a young fisherman named Manjiro was blown out to sea. He was eventually rescued by an American ship and taken to New Bedford, Massachusetts, where he was adopted by a whaling captain and took the name "John Mung." Manjiro/Mung became the best-known Japanese among Americans at that time. In 1851 he

returned to Japan, risking death to do so. Fortunately for him, by then he knew so much about the Western world and the United States in particular that he was too valuable for the authorities to imprison or execute.

Some of the information he gave to officials in Japan sounds surprising. In America, he reported, "refined people do not drink intoxicants, and only a small quantity if they do. Vulgar people drink like the Japanese." He also stated that "there are no baths in that country like those of Japan, but they use a bathtub," and that "toilets are placed over holes in the ground. It is customary to read books in them."

When it came to relationships between the sexes, "both American men and women make love openly and appear wanton by nature," he said, and "for their wedding ceremony, the Americans merely make a proclamation to the gods, and become married, after which they usually go on a sightseeing trip to the mountains. They are lewd by nature, but otherwise well-behaved."[1]

On the same subject, when Japan opened its doors to the West later on in the century, one early visitor found that "a Japanese courtship and wedding are both very curious ceremonies, and still somewhat savour of barbarism"![2]

In 1868 a group of 149 Japanese went to Hawaii, the first to leave without sanctions, followed by other groups to Hawaii in that decade. In 1869 a group of twenty-two arrived to start a tea and silk company under the leadership of a German merchant, John Henry Schnell, whose wife was Japanese. In 1871 Schnell and his family left for parts unknown, after learning that neither tea nor mulberry trees for silkworms would grow on the island.

Students were also sent from Japan as a part of the country's push to modernize, which was synonymous with learning Western ways. In 1871 a group of little girls ranging in age from 6 to 14 were sent to America in order to learn how to be good wives and mothers, Western style. Sutematsu Oyama arrived in the United States

at age 11 and left when she was 22. As the wife of the minister of war in Meiji Japan, she was active in the Rokumeikan, the upper-class entertainment center that emulated Western society in the 1880s. However, she never really learned to write Japanese well, and like many of those who return to Japan from overseas assignments today, Sutematsu learned that "Japanese society does not take kindly to those who have experienced something different, or who have special ability, particularly if they are female."[3]

Poor harvests in Japan and a heavy land tax were incentives for immigration in the 1890s. Rather than students, these immigrants were young single men seeking their fortunes. Often they were younger sons, farm boys who hoped to make it rich and return home. Because of discrimination and the lack of opportunity, many were never able to achieve their goal. Some, too, came to escape military service.

Along with the farmers came those from the seamier side of life, the rough characters, prostitutes and gamblers who preyed on the new settlers, most of whom came from the poorer, southern part of Japan, the Inland Sea area or Kyushu.

A "gentlemen's agreement" in 1907 prevented more laborers from entering; Japan agreed that only families would be allowed to emigrate. "Picture brides"—wives selected by choosing from photographs—were still permitted, until 1921.

What must these young women have felt as they set sail for a land so far away? Did they dream of streets paved with gold, a life of comfort beyond what they had known in Japan? If so, they were soon disabused of such ideas when faced with the requirements of hard work on the farm, plus all the burdens of housework and children, far from family and friends.

Evangeline Lindsley grew up in Washington state when it was a prime destination for Japanese immigrants. Looking back to the early twentieth century from

the perspective of her ninety-nine years, she remembers
those young Japanese wives:

> When the brides arrived in Tacoma, the first thing that
> the bridegrooms did when they met them at the boat
> was to take them uptown to the department store and
> buy them a pair of American shoes and put them in a
> corset in an American store—and the poor little things
> never knew how to clump along in the high heels—and
> those little tight skirts, you know.

> [On our farm] we had a fellow named Kaboda and he
> married the prettiest little Japanese girl. Oh, she was
> so pretty! She was just a doll. And the first thing he
> did was to put her in those high-heeled patent leather
> button shoes, and he bought her a purple princess
> suit and put her in a corset. That was a tight-fitting
> suit, all new, and the skirts were kind of long. My
> father said, "Kaboda, what in the world have you done
> to that charming little wife of yours?"

Kaboda declared that now his wife was American,
and she must dress American.

Becoming American was not an easy process for the
Japanese women, especially, says second-generation
Japanese-American Kikei Kikumura. Without the sup-
port system of family and friends, unable to speak En-
glish, kept at home by family responsibilities, and faced
with discrimination, wives and mothers found life espe-
cially hard. It took a special kind of strength to survive in
this hostile land. Kikumura's mother, Michiko Tanaka,
like other Japanese women, may have appeared "sub-
missive," she writes, but such outward submissiveness
hid an "inner strength and courage" that kept the family
going. Tanaka's own mother exhibited the strength of
many Japanese women. It was she who ran the family
business, as well as the family, to the point that her hus-
band was actually afraid of her.[4]

Loyalties must have been strained for those early
Japanese-Americans, unable to hold citizenship in their

adopted country. Evangeline Lindsley recalls an incident involving a well-liked farmworker named Sasaki:

> This was after 1912, because Woodrow Wilson was President of the United States, and William Jennings Bryan was his secretary of state, and we were having some flare-up with Japan at the time. Sunday morning it was, and Sasaki came up with the contractor who had contracted with my father. He wanted to know, if it were necessary, would my father release him from the contract.
>
> My father said, "Why do you want to break the contract? Why don't you want to carry it through?" Oh, they wanted to do that. "Then why are you asking me this?"
>
> Well, they hemmed and hawed around, and finally Sasaki said, "Maybe we go back to Japan."
>
> My father said, "Do you want to go back? Don't you like it here?"
>
> "Oh, no," Sasaki said, "I don't want to go back. I like it here."
>
> "Why do you think you have to go?"
>
> Of course my father knew. He said, "Sasaki, you mean you think that you can't stay here?"
>
> "Maybe I have to go back," he said.
>
> Then my father found out that they were in the reserves, they were all subject to military duty, and if they got called back to Japan, they had to go. So Dad said, "Why, Sasaki, you wouldn't go back and fight us, would you?" Oh, no, he didn't want to do that, but maybe he'd have to go back. So my father said, "Well, if you have to go, then I will release you from the contract."
>
> Of course, nothing came of that, because Bryan came out to California and met the Japanese foreign minister and they settled it some way or other, and they

were not called up, but don't you see, they were ready to go. . . .

Then there's another story. Sasaki had a baby that was born on our farm. They had a big name day, a big celebration, and they invited us down. They had it in our hop house, the place where the hops were dried, and they had big white cloths stretched the whole length of the drying room. Down at the end they erected a kind of an altar, and the picture of the emperor was there—I can still see that—and they dedicated the baby to the emperor. When the baby was born, Sasaki brought him up to show him to us, and I had just learned—I think I was in the sixth or seventh grade—that any child born in the United States was an American citizen, so I said, "Oh, we have a little new American citizen!"

"No," said Sasaki, "He is Japanese! Japanese!" . . .

"So that made me understand," says Miss Lindsley, "why the Western people were so suspicious of the Japanese during the war, as to who was loyal and who was not, although it was a terrible injustice. What was so terrible about it was not just that they separated them from the rest, but that they didn't protect their property. That was what was worse, I think."

The internment during World War II of more than 110,000 people of Japanese descent, two-thirds of whom were American citizens, in violation of their constitutional rights is a blot on American history. Internment in what my friend Vickie and other nisei call "concentration camps" was the culmination of years of discrimination in America. The California Alien Land Laws of 1913 and 1930 first restricted and then prohibited *issei*, first-generation Japanese-Americans, from owning or leasing land. Nor could they become citizens.

In spite of the many hurdles faced by Japanese immigrants in America, Japanese-Americans fought for acceptance and are currently considered "model" citi-

zens. Because of this, those who now come from Japan owe these early Japanese settlers a debt of thanks for making their acceptance a little easier.

Japanese sojourners today don't face the obstacles that their countrymen did in an earlier period, but that doesn't mean they don't have problems of their own.

2

Problems of Today's Sojourners

> My God! You've got to take the kid to the hospital
> and you've got to look up all this stuff in the dic-
> tionary, your husband doesn't come home from
> work and you don't know where he is and you
> don't know how to call and find out!
>
> —Wife of a "salaryman"

In contrast to earlier newcomers, today's Japanese may arrive on jets after a smooth twelve-hour flight rather than on ships that have tossed on the Pacific for two weeks. They may arrive stylishly dressed in designer clothes carrying Vuitton luggage, but they are still coming to a foreign country, and they do not come without apprehensions.

They're aware of violence in America's gun-happy society, brought close to home by the death of Yoshihiro Hattori, a Japanese exchange student in Louisiana, shot when he was mistaken for an intruder at Halloween time.

They worry about the reception they will receive, when they have read about cases of "Japan-bashing" in some parts of the country. Japanese ambassador Ryohei Murata says that "the Japanese have . . . gotten the impression that Americans have been bashing us con-

stantly."[1] They're aware of the attitude of the union leader Wesley Wells, who claims that, because Nippon-denso's Michigan plant has taken away jobs from his Dayton members, "we're at war with the Japanese, by God, an economic war."[2] They've read of the case of Vincent Chin, a Chinese-American who was beaten to death by an American who mistook him for Japanese, and who blamed the Japanese for taking jobs away from Americans.

They have legitimate reasons to be afraid. Most Americans do hold their country responsible for the U.S. trade deficit, and, according to a recent Gallup poll, only 10 percent think we can trust the Japanese; 43 percent "seriously consider" them "untrustworthy."[3]

As more and more Japanese have arrived in America, resentment against them has grown, so that racist confrontations have become more common, the *New York Times* reports. One woman was told to "go back where you came from."[4] There are those like the mayor of Wapakoneta, Ohio, who find it hard to forgive the Japanese for the suffering of World War II, and even in Bellefontaine, Ohio, whose model Friendship Center makes Japanese newcomers welcome, there have been mixed feelings. Some Japanese families there have complained of receiving harassing telephone calls.[5]

So it's not surprising that many Japanese look forward to their stay in the United States with all the enthusiasm of German soldiers being sent to the Russian front in World War II.

Not only do Japanese businessmen fear taking the blame for whatever economic ills Americans suffer, but they wonder how their wives will manage.

Unlike Japan, where public transportation is cheap and available, America lives on the wheels of its automobiles. Many Japanese wives have never needed to learn to drive, but here even a trip to the grocery for basic necessities almost always requires a car. As one newcomer put it, "If you don't drive, it's like you don't have legs." Those who do drive must adjust to driving on

the "wrong" side of the road and overcome their fear of fast-moving traffic on America's wide highways.

Language, of course, looms as the biggest problem. Noriko Horii smiles as she remembers her first trip alone to a supermarket. Feeling proud of herself for negotiating the aisles filled with foreign food, finding what she needed, and making her purchases in beginner's English, she breathed a sigh of relief at the checkout counter—until the clerk turned to her and said, "Paper or plastic?"

Strange customs can also cause confusion. Fumiko Yamaguchi visited her American neighbor and was offered something to eat. Being a good Japanese guest, she politely refused at first, waiting for her host to make a second offer. There wasn't one. "And I was so hungry!" she recalls with a laugh.

There are more serious problems, too. Jill Sakai spoke of a friend who couldn't take the lack of structure in America, compared to Japan where she knew all the rules for every situation:

> The whole society is turned around a structure. If you meet someone the same age, you say a word a certain way. With someone who is older, or has a higher prestige, you talk a little bit different—you're more polite, you bow a little lower—there are certain rules for every situation, and when they come to the United States, there is no structure. You can say and do and act any way you can, so long as you are within legal bounds, so some women get depressed because they go there feeling very insecure, and unhappy with that.

> I've had one friend personally who had to go back to her family because she was really going crazy. . . . I don't know exactly what happened; I know that they like structure, when they know what's going to happen, how people are going to react, what they're going to say, and what they're going to do.

The educator Jennifer Burkard Farkas calls it "especially disconcerting" when sojourners cannot rely on

familiar hierarchical systems to establish patterns.[6] No wonder Japanese employees' wives in America so often feel isolated, even when such isolation is self-imposed.

Loneliness is a big concern, especially for women living so far away from the support system of family and friends and for those with limited English, but some may prefer loneliness to the awkwardness of unfamiliar situations.

The wife of one executive wanted very much to attend a coffee held to welcome Japanese women to the area, but, not knowing exactly where the other wives were placed on the social ladder, she turned down the invitation. If she had mingled with those below her husband's rank, it might have caused them all embarrassment. Those in an English conversation group are also conscious of such ranking. As long as the wife of an executive from a company participates, the wife of another executive of the same company would not feel comfortable being part of the group.

Because of such difficulties in cultural differences, according to a survey conducted by the researcher Mary Eva Repass, "half of Japanese wives living abroad suffer psychologically to some degree."[7] In contrast to the husband, whose adjustment comes easier with the support of his coworkers and the security of his role in the company, the wife may feel afloat, at loose ends, not firmly attached to any cultural footing. Problems with communication and cultural differences put her on an emotional roller coaster, one minute excited about her new surroundings, the next frustrated and confused.

And homesick. It's especially hard when there's a death back home. Grandparents, a cousin, a beloved teacher—their passing was even more painful when the bereaved could not be there to work through their grief with others.

Children, of course, are the target of a great deal of parental anxiety, and, given Japan's competitive schooling system, their education is one of the main concerns of Japanese families relocating in the United States.

Uncertainty of the length of stay can add to this concern. Parents worry that getting off the Japanese educational track will derail their child's whole future in Japan, where success depends on getting into one of the top universities. Even though youngsters might want to spend more time with their American classmates, they have precious little time for that, when they're busy pursuing Japanese studies—many attend Japanese school on Saturdays—and keeping up with American classes, too.

Adjustment to American schools is a problem. Although there may be advantages to learning about a foreign culture, for Japanese children who are still becoming comfortable with their own cultural system there can be conflicts. Before adapting to the new school situation, students will typically go through an "alienation" phase that can be stressful and confusing, and that can manifest itself in physical ailments.

Yuriko Otani's young son spent an unhappy year and a half before his English was good enough to make friends at his new school; meanwhile his mother went to his school "almost every day" to confer with his teacher about his lack of progress and his frequent absences. Some children develop "school-itis" in the form of chronic stomach upsets or headaches.

The mother of a teenager uses the term "nervous breakdown" to describe the reaction of her son to his failure to adjust to his new school. One snowy night, when his father was away on one of his frequent trips to Japan, the boy, angry and upset, took off on a midnight drive to calm down, in spite of his mother's fears of an accident on the slick highway. Sure enough, his car slid off the lightly traveled road. He was convinced that he would freeze to death in the icy temperature, especially as he had not worn a coat in his hurry to get out of the house. After a long wait, he spotted a car and frantically waved a Help sign. It drove on by. The night was getting colder and the boy was beginning to give up hope when finally he saw more headlights in the distance. He waved again; this time the car did pull over. A middle-

aged man and his son came to his rescue, driving miles out of their way to take him home and refusing the money he tried to press on them. His Good Samaritan suggested that instead he pass on the kindness to the next person in need.

This incident had a happy ending. The boy decided that maybe America was not such a bad place after all, and that Americans were good people.[8]

Most children eventually do adjust, but it is a severe strain for mothers, especially. Husbands sometimes work harder than ever at their new jobs at first, trying to justify the company's faith in them, and their wives are left alone to cope with whatever difficulties arise. The sociologist Merry White notes, however, that only a small number of children continue to have problems in adjusting to overseas life.[9] It is to the credit of Japanese women that such families do adjust and learn to like the United States, to the point that it may be hard to leave. They learn to like the relaxed way of life, the give-and-take of American living, the importance given to the individual, and, especially, the space and more comfortable housing available here.

But return they must, and that brings problems of its own. Any move is hard, but returning to Japan, where everyone is expected to fit the mold, is especially difficult. Those who have had foreign experiences are considered somehow tainted, their Japanese purity defiled, by such contact with the outside world.

The man whom Marilyn Inoue's husband replaced told his children when they were on their way back to Japan, "'Don't tell anybody that you speak English' because if you speak English too well that means that you're not really Japanese anymore." This has prompted Marilyn, an American whose husband is Japanese, to ask herself just what it takes to be a real Japanese:

> OK, you can have Japanese blood, but if you leave, you're not Japanese. If you've lived there all your life and you don't have Japanese blood, you're not Japa-

nese. And you're not Japanese if only one of your parents is Japanese. When are you Japanese? What makes you Japanese? You can never come up with a good answer, but it seems to me that the only way to be Japanese [is] to be born there, never leave there, never become good at speaking foreign languages, even though you have to learn some, and then you might be Japanese. I don't know!

Haruko Ohara was also advised not to tell anyone they'd lived in America. Her nine-year-old daughter planned to follow the advice. An understanding teacher, however, asked young Reiko to share her American experiences with her classmates, and within a short while she was a popular student in the class.

Noriko Horii's daughter was not so fortunate. Feeling threatened because the student's English was better than her own, the English teacher declared that "America was not one of the countries she liked." When students come back speaking better English than their teachers, it upsets the proper order of things. When one student corrected his teacher's pronunciation he was made to feel so miserable that he eventually transferred to another school.

Newspapers call returnees like Noriko's daughter "third-culture kids," because now they are neither American nor Japanese. As outsiders, *gaijin*, they are often bullied by their classmates.

Even so illustrious a person as Masako Owada, the new crown princess, did not escape such treatment. Following her father's assignments to Moscow and New York, she came home to a less-than-warm welcome in Japan. After enduring abuse from classmates who felt her Japanese-ness had been diluted by her overseas experiences, she eventually transferred to a private school attended by other children who had lived abroad.

Dr. Robert Mockrish, who is the middle school principal at such an international school, the Canadian

Academy in Kobe, describes the problems of returnees at his school:

> The major problem, of course, is that because Japan is such a homogeneous society, when people live outside the society and have experiences other than purely Japanese experiences, there's a great difficulty for them, almost to the point of their being ostracized from the group.

Dr. Mockrish explains that it's a question of upsetting the harmony of the group, a concept evoked in the Japanese word *wa:*

> The word *wa* expresses more than just a group, it expresses a harmony that that entire group feels, and once someone is outside of that group or outside of the *wa*, it's very difficult for them to get back in without breaking the *wa*, or the harmony, for other people. So there's a real fear of people coming back in, bringing new ideas in, having new experiences, and so these people feel quite isolated. . . .

> Children have a great deal of difficulty, because they virtually become outcasts in the Japanese system when they return. Generally their language skills are quite poor because they haven't taken Japanese for that year or two years or three years. They fall behind their classmates. They have trouble wearing uniforms to school. They haven't been with their friends for the last three or four years, and the friendships are already formed, and the groups are already formed. It's quite difficult for them to break in. Even from a sports or club perspective, they haven't had the contact with the sponsors and teachers. The teachers don't necessarily know how to handle it and don't know how to make the kids feel more included, and so many times what happens to these kids is they end up being the brunt of hazings and bullying, or they end up leaving and coming to an international school.

That presents conflicts of its own. They think something like "I couldn't make it in my own system now, so I have to take second best."

Opting for an international school probably does mean opting out of the Japanese system permanently. Such ugly ducklings can, however, become swans in schools like the Canadian Academy. Dr. Mockrish continues:

After they've been there for a while and realize the ease with which they are assimilated into an international situation, they come to consider *that* to be "at home," and the Japanese system seems almost comical.

Again, it is upon the mother that the greatest pressure falls, for she's the one who is giving all her attention to the family and its problems; she's the one who's responsible for everything in the home.

Dr. Mockrish agrees that it's much harder for returning mothers than it is for their husbands because

for the male coming back and going to work in his company and picking right up with Japanese and being a Japanese male in a Japanese society is much more acceptable. The reason they went to America in the first place was because of his business so he actually has a certain status now, for having been in that situation and survived it and come back. Now he has gone through a rite of passage. He has done something that others have been unable to do. . . . It puts him at the top. So for the men now, all they have to do is fit into the routine and play the role of the Japanese male: go out drinking with the men, play golf, work hard, and stick to it, and they have a great deal of status based on that.

For the Japanese women, it's a different story. The fact that they have seen the choices available in the

United States is one of several dangers, such as glorification of the individual, which can threaten the tightness of Japan's lockstep world. It is almost as though it's feared that if one stitch of the fabric of Japanese society unravels, the whole warp and woof will be weakened. And it is on this tight social structure that Japan's economy is based, and on which their very security depends.

Dr. Mockrish describes the problems that women returnees face:

> The females, however, have to now come back in and fall into that role of the Japanese wife and mother, and that's much more difficult after you've experienced some freedom that people many times experience in the West and in the United States. . . .
>
> I think falling into the role of "my husband's going to be working all night, and I have to have dinner ready when he comes back, and I have to be a dutiful wife and take his shoes and shine them and press his suit when he walks in the door"—those types of things I think are really difficult. Not being able to speak her mind, not being able to branch out and have her own time—not having that freedom here, I think, is difficult.

Again, although Dr. Mockrish stresses that he has not made a careful study of the phenomenon, it is his judgment from "casual knowledge" that "most of the families that I see that have been here long term and that have lived overseas have made the adjustment, at least from the point of view of school-community relations."

What is the source of this strength that allows the Japanese woman to overcome the many challenges of an overseas assignment, this inner strength that is not evident at first, but that may indeed reflect a kind of matriarchy? To answer this question, and to understand the vantage point from which Japanese women view their American experience, we need to know "where they're

coming from." Japan is a country where, among other things, values of self-discipline, endurance, and harmony strongly influence ways of thinking. Let's take a look now at Japanese society and where women stand in it, as compared with the United States.

I've divided this section into two parts, the private sphere and the public sphere, for, although Americans would like to move easily between both, for the Japanese there is a clear distinction.

II

Women in Japan:
The Private Sphere

3

Household Managers

> Haruko was far more than the official arbiter of
> taste and the authority on social propriety. She
> was Superintendent of Daily Life, the Office Man-
> ager, the Inspector-General, the checker of every-
> thing that entered and left the house. . . . Haruko
> was the Camp Mother, the Head Counselor in
> charge of five campers—their laundry, their stom-
> achs, their education, and their general life and
> deportment. She barked orders all day, like a
> Master Sergeant.
>
> —Gail Lee Bernstein, *Haruko's World:*
> *A Japanese Farm Worker and Her Community.*

Why has women's liberation not been the factor in
Japan that it has in the United States? Knowing what
it's like to be a Japanese housewife can help to answer
this question, for, from the Japanese perspective, life in
the private sphere has many advantages over that in
the very constrained public world of Japan. Among
these: status and responsibility, power and control, and
a freedom denied to those—mostly men—in the public
sphere.

As Joy Hendry and Alan Roland, among others,
have noted, there aren't many countries in which

housewives and mothers warrant the respect that they have in Japan.[1] While it may be denigrated in other places, including the United States, the role of house-wife is one that Japanese culture and the women them-selves feel holds great importance. There are those, like the sociologist Sumiko Iwao, who think that the women's liberation movement in America is a mis-nomer, since women, rather than being liberated and expanding their horizons, have instead seen their world narrowed. The demands of a professional career are every bit as confining as those of hearth and home. The typical Japanese woman, in contrast, feels that since she is in full charge of the home, she has no need to seek further responsibility in the outside world. This responsibility in itself grants her the status she enjoys and a respect that housewives in other parts of the world might envy.[2]

Separate, but truly equal, is the way most women in the home today see their calling.

Not to be underestimated is the influence that Con-fucianism has on Japanese thinking. Confucianism stresses education and respect for family and authority. It has affected everything from ways of doing business to Japanese psychotherapy: Confucian loyalty to old ties in business makes it hard for newcomers to break in—and how can you blame your parents for your problems when you're supposed to honor them?

Confucius, born in China in 550 B.C. said "harmony is to be valued," and to achieve that harmony he insti-tuted a value system based on human relationships, rather than on any abstract ideals or principles. "Do not do to others what you would not have them do to you," he said.

Important to this harmony was a system of order, according to which society was divided into five human relationships: ruler and subject, parents and children, husband and wife, elder and younger, and friend and friend. A class system was also instituted, with scholars

(or scholar-warriors later in Japan) at the top, followed by peasants, craftsmen, and merchants.

Confucianism stressed good government—there were civil service exams in China by the seventh century. It emphasized that all citizens play different, but equally vital roles in society, and they should commit themselves wholeheartedly to their individual roles, for the good of the group as a whole. That role should not be diluted by attempting dissimilar goals, by trying to handle family responsibilities and office tasks at the same time, for example.

Just as men expect to commit themselves heart and soul to their work, women, too, consider their careers as housewives to carry the same commitment.

Although of course there are women who do not see themselves cut out for the domestic life, who feel their talents would be better used elsewhere, most Japanese do, in fact, prefer the status quo, in which men earn the income while women stay at home. Neither men nor women see this division as discriminatory, for women exercise a great deal of power in their world.

But is this fair to the individual? Betty B. Lanham notes that "fairness" takes second place in the Japanese value system, after other more important values of harmony and "feelings of cordiality of all members of a group." What is more, "individualism" connotes "egotism and a lack of concern for others."[3] Self-discipline, perseverence, and patience rate higher in both Buddhist and Confucian traditions.[4]

Confucianism, which did in fact place women on a lower level, can be a bane for those women who would seek a different path, but it is also a boon for those who follow tradition, since it stresses the importance of family. Japan has long considered the family essential for maintaining a prosperous and stable society. This idea also contributes to the status of the housewife.

So whereas an American wife and mother might consider her outside activities more important than

what she does at home, a Japanese woman doesn't look at it in the same way. An American woman might put herself down as "just a housewife," but her Japanese counterpart considers homemaking a true profession. It's a role that many women take very seriously; skills shown in popular women's magazines could make even Martha Stewart's efforts look shoddy. Applying themselves to household tasks with care and creativity gives them the sense of accomplishment of a job well done.

Japanese women picture themselves as acting behind the scenes but feel they are just as important as the actors on stage. Or they are like the foundation of a building, not as evident as the rest of the architecture, but nevertheless indispensable.

That's the way Masako Miyagi sees it. A trim, neat woman in her midfifties, she is dressed sensibly in a yellow and brown skirt, yellow sweater, brown blazer, and low-heeled brown shoes. Poised and serene, she sits erect in her chair, hands folded, as she describes how the mother in the family must provide stability. She wants to be "like a cornerstone of the family," she says:

> I think my role as a mother and a wife is to be the center of the family, but not outstanding, but below, underground at the center, so everybody feels comfortable when they think mother is here, wife is here, in the home. It doesn't actually mean I stay home, but they have me as a mother, as a wife, at home. And they feel I am available whenever they need my help. . . .

After all, Japan is not like America, where "people need to express themselves in visible and audible ways," she says. What is underneath, hidden, and understated, can be important, too.

Consider Japanese art. In line with Buddhist thinking that in this fleeting life there is much that can only be glimpsed or hinted at, what is not drawn but left to the imagination is important, too. As in Haiku verses, what is not said is just as important as what is expressed.

The tea ceremony, says Masako, is a very good example of the Japanese culture. "We don't speak a lot in the ceremony but still we understand; we appreciate the feeling; we understand each other's feelings without saying anything."

Not only are housewives responsible for the spiritual or emotional well-being of the family; they are also in charge of their material needs. An important task that most housewives assume is that of control of the family finances. More than three times as many Japanese women manage the household budget as do American women, and more than twice as many are in charge of the overall financial planning.[5] Because of this, even though their income may derive in all or in part from the husband's salary, 40 percent of full-time housewives, and 70 percent of married working women in Japan consider themselves economically independent.[6]

The authors of an article aimed at American readers recommend that American housewives who suffer from low esteem can remedy this problem by assuming control of some of the family income and by treating it as if it were a salary.[7] Significantly, this is something that Japanese housewives traditionally do. The typical wife will manage all the household and financial decisions, often including stock market investments, remitting some 15 percent of his income to the husband.

Japanese women in the United States continue this tradition. Almost all I interviewed stated that they were in charge of the household accounts. Where, I was asked, could you buy that essential tool, a household accounts book?

Dr. Elenore A. Koch, who teaches Comparative Sociology in Japan, gives one example of what she calls the "independence and strength" of Japanese women who control the family pocketbook.

A Japanese friend told her one day, "I'm going to pick you up in my car. I just bought a car."

"You did?" said Dr. Koch, "What does your husband think?"

"Oh, he doesn't know yet," her friend replied.

"Will you tell him?"

"Of course," she said, "but when I am ready!"

Dr. Koch emphasizes that in Japan "the female has tremendous power because she has the money, the finances, and she has total responsibility for the household, the small community where she lives—all that organization is hers."

Because most husbands are totally involved with their jobs and have turned over all responsibility for the family and for managing their salaries to their wives, the latter have a great deal of authority. This power has granted to Japanese women a psychological freedom that American women may be lacking.[8]

Having such control of their own lives is something that the men might envy. Women have been able to develop their own interests and abilities, within certain bounds, and become a more diversified group of people than their husbands, who, through job requirements and peer pressure, are beginning to look more and more like cookie cutter clones.

Consider the working day of a typical "salaryman." He rises early to face a commute of up to two hours on public transportation, which might mean standing for a good part of the trip. At his destination he works his way through the crowd—over a million people pass through Tokyo's Shinjuku Station every morning—and arrives at the office for a workday that will not end when he leaves his desk. After-hours entertaining of customers or socializing with coworkers away from the structured office setting is an important part of building and maintaining relationships, those human relationships so important under Confucian precepts.

In contrast, Marilyn Inoue describes the freedom that awaits Japanese women when a child reaches school age. Unlike men in the workplace, they "don't have to deal with awful bosses," she says. "Once they get the kids in nursery school, a lot of them go out during the day, and they have hobbies, or they meet their

friends for lunch, or they go to the bookstore, or go to the local culture center, and they get all kinds of arts and crafts classes, and foreign language classes. . . ."

Are Japanese women willing to give up this freedom, along with the power and status they now enjoy in exchange for "equality"? No way. To women faced with the choice of the role of housewife or that of a career woman in today's business world, which is stressful for men as it is, and much more stressful for women, the answer seems clear. For Japanese women are, first of all, practical.

It is this pragmatic approach that allows women to adapt themselves to the situation. Pragmatism might mean providing the best home environment possible, since that's considered essential for the success of the breadwinner. In the traditional family where the wife maintains the household, the husband is free to give total attention to his career, resulting in rewards in which the wife shares, both in income and in high status.

Apparently this approach works for some American families, too. A recent study among male managers at some twenty Fortune 500 companies showed that there is a large gap between the income for men in two-income families and that of men whose wives do not work outside the home. From 1984 to 1989, men who were the sole breadwinner saw their salaries rise by 70 percent, compared to 59 percent for those with working wives, presumably because with fewer at-home responsibilities the former were able to concentrate more on their jobs.[9]

In Japan women are important not only for their own families, but for the national economy as well. The willingness of Japanese salarymen to put in long hours every day has been credited with Japan's economic growth. Without the support of his wife at home, the husband would never be able to be so centered on his company. Deborah Fallows refers to Japan's dedicated housewives as the country's "secret weapon." Not only do they make it possible for their husbands to contribute to Japan's economy, but they provide "the insur-

ance that the next generation of Japanese will behave in the same hardworking way," she says.[10]

There's another reason why the Japanese economy is dependent upon Japanese women, says Dr. Koch. Japan's high savings rate enables Japanese businesses to draw on large amounts of capital. And who is responsible for that savings rate? The Japanese housewife, the one in the family who manages the money, and who can conveniently make deposits at her local post office as she runs her daily errands.

It is not surprising then, given the relative autonomy, power, and respect that Japanese women enjoy in the domestic position that they are generally satisfied with that role.[11] For the time being, at least, most are happy with this. As "Sachiko" says in James Trager's *Letters from Sachiko: A Japanese Woman's View of Life in the Land of the Economic Miracle*, "Here, of course, we are just as happy not to mix in our husbands' business affairs and not to have our husbands encroach on our territory."[12]

In fact, studies show that Japanese women seem more satisfied with their lives than do Western women. In answer to a 1990 survey question: "Do men or women have more of an advantage in society?" only a minority of Japanese thought that men did, while in the United States more than 40 percent of both men and women thought that men had advantages over women. In the same survey, 64 percent of Japanese women thought women had more respect than they did ten years before, whereas 55 percent of American women felt so. And, whatever the true situation may be, both men and women in Japan felt that the status of women had reached a satisfactory level. Women were "quite optimistic about their situation."[13]

There are other reasons why Japanese women value their roles, beyond a sense of power and control over their own lives. Home is associated with the good things in life: warmth and comfort, whereas the outside world can be a cold and uncaring place.

There's a certain status, too, in being in a family where the wife does not have to contribute to the income. In fact, the more educated the husband, the less likely the wife is to work. The situation is not unlike that in the United States of an earlier period, when a husband would proudly proclaim, "No wife of mine will ever have to work!" Part-timers are more likely to work because it is necessary to supplement the husband's income, but full-time female workers, unless they're one of those elite career women rarely seen, tend to be those whose low economic situation demands full-time pay.[14]

If the advantages of the domestic role are the "carrot" then, it is social pressure that is the "stick" that keeps women, at least those with children, from seeking more than they do in the public sphere.

Of course, people in every culture want to fit in, but pressure to conform is greater in Japan. In America, says James Fallows, we think: "People's lives should change! The future should be full of surprise!" In Japan, however, doing "*the expected thing*" is a virtue. "The ideal Japanese life," he says, "is one from which uncertainty has been removed as early as possible. . . ."[15]

Haruko Ohara describes what such pressure was like. With an oval face framed by shoulder-length hair and blessed with Katharine Hepburn cheekbones, Haruko gives the impression of being taller than she is. Although she's not without a sense of humor, she seems to take life seriously. She goes through her day with quiet determination, a determination that has gotten her through challenging correspondence courses in demanding subjects.

Haruko recalls:

> When I was twenty-four or so, [I thought] I have to get married, and I have to live that way, or once I got married, oh!—I have to have a child, or after I have a child, then I have to give up my job. Nobody told me, but I felt that way.

It was not just her parents, she says, but the whole neighborhood that exerted subtle pressure to shape her future. Social pressure, much stronger in group-oriented Japan, status, and the relative power and freedom of the housewife's life are all factors that work to maintain the status quo.

4

Wives

In public a Japanese wife would never shame her husband by scolding him or disagreeing with anything he says. But behind closed doors in her own bailiwick (but never so loud so that the neighbors might hear), he might get an earful. . . .

—Jane Condon, *A Half Step Behind:*
Japanese Women Today

Social pressure may lead to acting as expected in public, but what you see is not necessarily the whole story. In line with maintaining Confucian harmony, how one acts in the outside world may have little relationship with how one really feels, and how one acts in the privacy of one's home may have little relationship with the face presented to others. Sincerity, in Japan, means living up to your expected role, whereas in America, the same word has a different meaning. It's considered insincere and somewhat dishonest if we don't reveal how we really feel.

The Japanese have some terms for this dichotomy in Japanese behavior. *Tatemae* refers to what's perceived on the surface, *honne* for one's true, inner feelings. In the same way, *soto*, "outside," is contrasted with

uchi, "home," and it's not at all hypocritical to take on a different face for the different situations. Again, it's relationships that count. Situational ethics, rather than abstract principles, guide behavior to keep things running smoothly.

So what looks like a patriarchy in Japan may indeed be one—in the public world—but a kind of domestic matriarchy prevails at the same time.

If that's the case, then what is the place of the male spouse in a Japanese home? Not only do women have control of their own lives, but apparently many control their husbands' lives, too.

Unfortunately, because of the man's one-sided role and his dedication to his job, some men have actually been made to feel like strangers in their own homes. One man complained that he could hardly move the furniture without his wife's permission.[1] And Yuriko Otani, the wife of a "salaryman," proudly reports that "this Tuesday my husband wanted to play golf, but he had to ask if it was all right with me first!"

The sociologist Sumiko Iwao, for one, thinks that the traditional pecking order has even been reversed. Women not only consider themselves their husbands' equal, but the men admit that they are dependent upon their wives, and so, in a way, are inferior to them. Instead of the traditional obediences of early times, when a woman was obliged to obey first her father, then her husband, and then her son, it's said that now there are three obediences for men. When they are little, they must obey their mothers; as adults, their companies; and when retired, their wives.[2]

In the same way that Japanese women weigh the practical aspects of a career decision, they take a pragmatic approach when it comes to choosing a spouse.

The three "highs"—high education, high salary, and physical height—are at the top of the list of qualities demanded in a husband these days. Japanese women are not apt to be swept off their feet; this attitude may be one reason for the recent tendency to marry later in Japan.

An indication of this pragmatism can be seen in the Virginia Slims Survey of 1990, in which Japanese women rated financial security and having children more important in a marriage than did American women.[3] The third most important reason for marriage in Japan was "financial security" while it ranked a distant eleventh in the United States.[4] Another survey shows that four women out of ten consider money to be the most important reason for choosing a husband.[5]

Japanese women living here agree that they and their compatriots take an objective view of wedlock. They "don't expect too much from marriage," Keiko Koga thinks, unlike American women.

As Midori Yamamoto says, those in Japan

> don't think about love. . . . I had a friend from college who dated many men—she was a beautiful, beautiful girl—but she said when she was in school, "Marriage and dating are different things. I date as many as I want, but when I marry, I marry a person from a nice family, who graduates from a good university." And she is still married, and she has three children.

Yoshiko Hanai agrees that Japanese women are "very, very practical," and that they "are not emotional like American women." Rather than thinking of love, they consider the financial circumstances of a potential husband, she says.

About one-fourth of today's marriages come about through *omiai*, a kind of blind date arranged through a go-between who, presumably, has investigated the suitability of both partners. The couple can decide after a few dates whether they feel they are compatible and, if not, they're free to try again. One woman I know finally found her Mr. Right, an orthopedic surgeon, on the twelfth attempt.

Once they are married, communication may be a problem between couples. The ideal Japanese man is a stalwart silent samurai. He bears everything without

complaint and never reveals his personal thoughts and feelings, especially to his wife.

Japanese women, on the other hand, like women everywhere are apt to talk much more. Males and females in this country, too, have different communication patterns. In spite of how natural these language differences may be, however, there is evidence that today Japanese women are changing. They're better educated than in years past and feel a strong, albeit frustrated, need to communicate.[6]

This failure to communicate, exacerbated when husbands come home late and tired, may be the reason for the recent phenomenon of the "sexless marriage" reported by the media, says the psychologist Kumiko Muramoto.

Although the divorce rate in Japan remains low, this fact is no indication of how many marriages are truly successful. "Masked marriages" is a term that has been coined to describe unhappy unions. The couple may present a happy face to outsiders, but reality is a different matter. Rather it is social pressure and other factors, including the fact that divorced women rarely receive child support, that keep the couple together, given the pragmatic expectations for married life.

In a typical evening scene, the husband

> briefly acknowledges [the wife's] remarks, and, if he hears something that displeases him, is quick to criticize, reproach, or blame her for bad judgment. He rarely listens attentively or offers advice or support, simply grunting assent or approval.[7]

"*Meshi! Furo! Neru!*"—"Food! Bath! Sleep!"—might be the only words he says to his wife.

American women, on the other hand, expect too much communication, according to Masako Takita. She thinks this is a factor in the high American divorce rate and that the couple's relationship is different, but not

better, in the United States. In Japan, she says, "good speech is silver and silence is golden," but in America:

> All the time, you know, the wife and husband say "you love me, I love you," then whoever has a love affair outside cannot say, "I love you, Honey," so the wife will find out right away, but in Japan, they don't say, "I love you, do you love me?" They don't say this, so whatever the husband is doing, the wife doesn't know!

Women may not always find their husbands' company fulfilling, but they do enjoy outings with other women, when they can let their hair down. To have a really good time, no men should be included in the get-together, they feel. On female-only outings, notes the anthropologist Takie Sugiyama Lebra, the noise level—and the bawdy jokes—"would surprise those who hold a stereotype of quiet, reserved Japanese womanhood."[8] Spend a couple of days at a hot springs resort, and it's hard to say which group—segregated—is having more fun.

Masako looks at the annual outings to such resorts with her old high school chums as "a learning experience," an opportunity to discuss problems and to seek advice and comfort from old friends.

In the farm community Gail Lee Bernstein describes in *Haruko's World: A Japanese Farm Woman and Her Community*, couples seldom go out together, calling it "embarrassing"; women think it is too expensive, and men find it boring. Farm couples see enough of each other anyway, since they work together every day. "No wonder so many people get divorced in the United States," says Haruko. "No wonder they feel constricted. It is a strain always being with the same person."[9]

Especially when people are living longer and longer, a little less togetherness would be more in order if a couple hopes to stick together over the years. That's the Japanese view.

Again, Japanese women are pragmatic when it comes to making a marriage work. Midori Yamamoto's advice is to accept one's spouse "as a person, instead of expecting too much of this ideal that you have. You can't mold your partner into that ideal that you have, because that ideal itself is something that you can't touch, you know. So what you have here is not a reality; there's nothing there."

It is a good thing that Japanese women are so pragmatic, for if they are looking for romantic relationships, apparently they are in the wrong country. In an article titled "Workaholics they may be, Oriental Don Juans they ain't," *The Japan Times* reports that an international survey found that "on questions of romantic behavior and attitudes, Japanese men most often hit the bottom of the list"![10]

There's a common saying that a good husband is one "who is healthy and not here," and at least one survey supports the fact that wives definitely don't want their husbands in their way at home. Since wives have more free time to develop their interests, they may find their husbands, who have limited their activities to work-related ones and failed to grow in other ways, become boring, especially by retirement age.[11]

It's no wonder then that it is when men retire that marriages are most in danger. As late as 1930 the life expectancy was only in the early forties, but today people in Japan are living to about eighty, the longest life span in the world. That means a lot of time in each other's company for couples who have lived separate lives during the child-raising and working years.

More and more couples are living separately, although still legally married. Company transfers have contributed to the trend. A modern Japanese phenomenon is that of the husband who works in a location away from his family, which has given rise to a Japanese expression for such situations, *tanshin funin*, "solitary job assignment." The very term implies loneliness in this group-oriented society. Many women find, however, that

they don't really mind at all; it's one less responsibility in their lives.

With the division of labor so common in Japanese families, often wives seems more like mothers to their husbands than equal partners, as in the ideal American marriage; Japanese wives tend to "baby" their husbands, treating them more like children than responsible adults. This behavior is considered quite normal. Husbands expect to be spoiled by their wives, and, as mother figures, wives find it easy to dominate. It's also much easier to accept a spouse's peccadilloes if he's thought of as a naughty child; adultery is taken much less seriously than in the United States.

"After they get married," says Fumiko Yamaguchi, "Japanese men need mothers again to take care of them, so [the wife] has to change from woman to mother for the children and for the husband."

Midori Yamamoto agrees:

It seems like more and more men are becoming more dependent on women, because of the way they grew up. The moms are there all the time to do everything for them, so when they graduate from school, they start work, and they are very good, very smart, very intelligent, but then they are so used to just getting information to prepare for the test. Information is not knowledge. They are very, very good at doing things that they are told to do, but then beyond that, to get out of that situation and become more creative, using that information that you've accumulated through the years and to use it in society—people say, well, they're not really good at it. . . .

There are magazines that tell them what to do. They don't even know how to ask for a date, because they haven't done that. They're called "the catalog generation"—they have to have something that tells them, and the Japanese young girls are getting tired of it.

Four or five years ago there was a big trend with the young Japanese girls who were in their twenties falling

in love with married men . . . because those young girls are dismayed with men of their same generation, who cannot be real men.

Dr. Elenore A. Koch, speaking from her experience as a college teacher in Japan, sees a parallel between this situation and the "Momism" in America described by Philip Wylie in his postwar book *A Generation of Vipers.* "So when we talk about Momism [in Japan]," Dr. Koch says, "we're talking about the male who is brought up to be totally non-male, almost androgynous, you know, very innocent, very child-like. In university they behave like sophomores in high school."

All this psychological dependence upon Mom has given rise to the term *mazakon*, from the English words "mother complex." Why are so many grown men acting like "Mama's boys"? Japanese mothers, in their role as "supermoms," get the blame.

5

Mothers

[Japanese mothers are] Japan's secret weapon. They make a good Jewish mother look uncaring. . . .

—Ross Perot, 1992

Of course the most important homemaker role is that of mother to the children. It's motherhood, not wifehood, which gives a woman a sense of accomplishment, and it's the children around which the family revolves.

As we've seen, the mother has complete authority in the home, since many fathers have abdicated their role as head of the household in order to devote themselves to their jobs. Dr. Elenore A. Koch emphasizes that "the husband has *no* responsibility for the house, and *no* responsibility for the children." So absent can the father be from family activities that one educator in Japan mentioned that until her child was four years old the girl thought her uncle was her father, having seen so little of her father.

Back in the 1950s in the United States there was an article about "the problem of the intelligent woman." How was she to use her brain? A cartoon appeared, too, in which one matron said, "We're sending our daughter to college so she'll have something to think about while

she does the dishes." As in America of the 1950s, in today's Japan, as Dr. Koch remarks, "the lack of the use of her intelligence weighs heavily on the female." Many women have dealt with this problem by devoting their talents to making a real profession of parenthood. A woman with education but without marketable skills can devote all her abilities toward molding her children.

Apart from the fact that practical Japanese women know how to make the most of what are limited career choices, the raising of children is considered too important to leave to outsiders. In Japan it is a demanding job:

> Small children are taught how to accomplish various tasks they must learn through patient demonstration and repetition, a principle which applies even to the most basic activities such as eating, washing and eliminating, elsewhere often left to children to pick up by themselves. The aim is to inculcate habits for life in the child's body, and these should be passed on as early as possible. A good mother is one who does everything for her child.[1]

Seldom are the mother and child separated in the early years. A mother bathes with her child, sleeps with her child, and traditionally carries it on her back as she goes about her daily chores. Baby-sitters are not part of the Japanese scene; children accompany their mothers everywhere.

Marilyn Inoue describes the thinking behind what she calls the "superoverindulgence" of children in Japan:

> What Japanese people think is that any person who does anything that's bad or obnoxious or annoys other people—it's because they have an unfulfilled need, and the way to make your child a good person who will be a good, conforming, considerate person in the future is to fulfill all the normal childish needs, so that's why you give the kids whatever they want whenever they want it, even if they interrupt an adult conversation, because the children really need it, or they wouldn't

ask for it. They wouldn't act up to get the attention. Kids will wake you up in the middle of the night because they have a need. They'll come and climb in your lap because they have a need. They'll cry in public, because they're tired.

OK, they're probably tired and hungry, so give them a little cuddle and hand them a cookie.

One time I was at a Buddhist temple, and I thought my kid was fine. I thought I'd fed him and given him everything, you know, and he started crying and making a tremendous fuss right in front of this Buddhist statue, and I was so embarrassed. A Buddhist nun came out, with the shaved head, an old, old lady, and she goes up to the Buddha altar and she takes off cookies—because people bring cookies, crackers, and stuff and offer them—and she picks up this package of cookies off the altar, and she says, "Oh, Buddha won't mind!" and she gives each kid a cookie, and they immediately settled down.

So people think that you should give the child everything and anticipate the child's needs. They don't wait until the child cries. And I think when you look at very small Japanese children—I've seen them kick and hit their mothers and call them names, especially boys— you think, "That kid's going to grow up to be an animal!" You see that kid ten years later, and he's the nicest young man you'd ever want to meet!

If you're a good mother, you'll figure out what your child's unfulfilled need is, and then he'll be a good child.

She adds that "you're a slave to your child" until he or she enters nursery school, an event that mothers really look forward to.

Marilyn was impressed by what she once read that in Japan, where mothers anticipate the child's needs, Japanese children learn to wait passively, while American children, who must ask for what they want, learn to reach out.

Mothers look to their children's welfare and disregard their own to the extent that motherhood is commonly considered a hardship; a mother is expected to suffer. American mothers are unlikely to bear such burdens so willingly, but in Japan, you can't be a real mother without suffering, and mothers are admired for this trait.

Mothers learn to play upon their own suffering as a form of discipline for the child, through the child's guilt. Merry White calls the ability of Japanese women to produce guilt in others "a cultural art form."[2]

For a child to be successful in life, it's thought, he or she has to have a good relationship with a devoted mother, and one that's based on dependence. The Japanese have a word for this kind of dependence: *amae*, which, curiously enough, is closely related to, and written with, the same character as the word for "sweet." To be a healthy, normal human being, you must be able to trust others enough to be able to depend upon them, and you must also be able to let others depend upon you.

While for punishment an American child might be sent to his room, a Japanese child would be sent out of the house, to the cold and harsh outside world, to make him value his dependence on home and mother.

At the opposite end of the spectrum, consider what the American family psychologist John Rosemond has to say in his syndicated column. In an article titled "Mothers: Get Out of Children's Lives," he describes the "unhealthy" relationship some mothers in the United States have with their children. "Many, if not most women, . . ." he says, "are encouraged to believe that the success of the child-rearing process rests exclusively on their shoulders, and their shoulders alone. The encouragement is insidious to our culture." His description of the kind of mother not to be in America, one who can't separate her own emotions from that of her children, and who feels that the more she does for her child, the better parent she is, sounds very much like the ideal Japanese mother![3]

In the "nature versus nurture" debate, there's no question that in Japan "nurture" wins out. Children are like clay, to be sculpted into well-behaved, successful persons, twigs to be bent into the shape of sturdy trees. This approach places a huge responsibility on the shoulders of the full-time mother, who has no one to blame but herself if her children do not come up to expectations. If they fail, so does she.

Although most mothers accept their role proudly, the grave responsibilities of motherhood in Japan can be a heavy burden that some are not capable of bearing, according to the psychologist Kumiko Muramoto. A mother of young children herself, Muramoto-san counsels women suffering from postpartum depression, a common problem now more than ever, because many young mothers are isolated in apartment buildings without the support of an extended family. Women who have been out in the working world especially miss the freedom of their former life-style. Muramoto-san says that one factor contributing to such depression is the very strong "mother myth," which women take very seriously. "It is hard for many women to live up to that image, and they feel that they have failed," she explains. Child abuse, too, although it occurs far less often than in the United States, is on the rise along with the nuclear family.

Not every woman can fit the mold, even in the face of social pressure to do so, but if one can handle the responsibility, there are compensating rewards, self-esteem among them. Many women find a sense of self-validation in their roles as mothers, and there is the satisfaction of knowing that human warmth itself is associated with motherhood. Although mothers might be blamed for their children's failures, conversely if the children succeed, the mothers share in this success.

As in an earlier age in the West, when sentimental songs about Mother were popular ("*M* is for the many things you taught me. . . ."), society respects the motherhood role. Although little help may be forthcoming

from the male parent in the family, the government is generous in its support to mothers. It offers free check-ups, advice, home visits, plus a nationwide program of "Parent Education Guidance" with information, lectures, and classes.[4] Mothers in Japan receive many more benefits than their American counterparts.

Marilyn Inoue, whose children spent their preschool years in Japan, compares her Japanese experience with that of being a mother in America:

> I guess the only thing I envy, and it wasn't until I came back here—I don't think that parenthood is a respected profession in America. When people ask, "What do you do?" and I say, "I'm a housewife," they turn around and start talking to someone else because they assume that you have nothing else to say, which is very distressing. I overheard a girl in McDonald's one day, and she was looking at my kids, and she's looking at me and she says to her friends in a very superior tone of voice, "*My* mother has a *real* job."

> The thing I would envy Japanese women is what they do is respected. I mean they're restricted to it, that's why I feel sorry for them, it's an "either/or" position, but at least their work is respected. Contrary to popular opinion, there's probably nothing more respected than a mother in Japan. Of course you have to conform to all the things that "make a good mother," but people don't assume that you're not really working. People don't think you're some dummy who doesn't know how to do anything else, which I feel people sometimes think here.

As a full-time mother, Marilyn says she's "pretty much in the same position" that she was in Japan, but with one big difference. It can be a lonely job in America:

> It's actually worse for me here being an at-home mom, because there are no daytime events. A lot of women in this neighborhood don't work outside the home, or they do things like they clean the day-care center in

the afternoon, the similar part-time things, but there are no day-time classes in anything, practically. You can go to a writer's discussion group or something like that. That's virtually nothing. All PTAs are in the evening. The women voters meeting is in the evening. There's even a group called "Formerly Employed Mothers at the Leading Edge" or something, but they meet in the evening! It's an evening meeting!

In Japan, on the other hand, if you're a mother you know you can count on support from friends, neighbors, family, government, school: the whole country. Children are the future of the nation—its survival depends on them, and on their education—and their upbringing is a proper and indispensable task. In America, too often you go it alone.

Education

One of the most important roles of a mother in Japan is that of educator working in tandem with the schools. Teachers count on mothers to prepare supplies, help with homework, and follow their child's progress closely.

Not only is the importance of education one of the major emphases of Confucianism, but education is also the door to opportunity in the country today. If a student can pass the tough entrance exam to one of Japan's top universities, his future is ensured, since the best jobs go to those graduates.

So important is education that the family may separate if the father is transferred and the mother will remain behind with the children if they are in a good school, since she's the one in charge of their education. Or a child may be left with relatives, even if the family is going abroad, especially if that child is a boy. Boys especially feel pressure to do well from nursery school days on, all with the goal of getting into a leading university.

The pressure is not so intense for girls, however. Keiko Koga, who lives in the United States, knows that her daughter is well behind her Japanese contemporaries in such subjects as math, but she doesn't worry, because "she's a girl!"

Perhaps Keiko is just being practical. It makes more financial sense to invest time, money, and attention in the education of sons, who will have to support the family. Whether it is unfair or not, Keiko's daughter will probably be gently nudged toward a career as a housewife, and her brother will get more of her mother's attention.

Are such assumptions changing in Japan? Midori Yamamoto isn't so sure. Things "may be changing," she says, "but still I think the moms spend a lot of time with their boys. It has a lot to do with the Japanese entrance examinations for school." When I asked her if indeed mothers today still feel that education is more important for boys than for girls, she replied:

> Oh, yes! Very strongly. The mothers want the son to go to a university that has more prestige. That way his life is set, they think, so they spend a lot of time with them, and the mothers do not want their sons to be doing things like helping the mother. . . . Those kinds of things. The mothers do everything so the boys will spend their time studying.

Mariko Yoshino remembers the efforts put forth to see that her brother succeeded:

> My brother was getting up early in the morning every day, and at that time, you know, Japanese houses, especially old Japanese houses, did not have a central heating system, or any kind of fancy heating device, so my mother had to get up at 3:00 in the morning to start the charcoal heater, and she prepared nutritious food for him, so she had to be up for thirty minutes or one hour before my brother was up, so that the room was heated for him to study. . . . I remember my

mother making juice out of fresh fruits and vegetables every morning, which she didn't do for my sister and me! They spent a lot of money on us, but he was treated the best, I think!

Like stage mothers in the West, behind every star pupil in Japan is a mother who is completely involved:

> She studies, she packs lunches, she waits for hours in lines to register her child for exams, and waits again in the hallways for hours while he takes them. She denies herself TV so her child can study in quiet and she stirs noodles at 11:00 P.M. for the scholar's snack. She shuttles youngsters from exercise class to rhythm class to calligraphy and piano, to swimming and martial arts. She helps every day with homework, hires tutors, and works part-time to pay for *juku* [cram school]. Sometimes she enrolls in "mother's class" so she can help with the drills at home.[5]

The *kyōiku mama*—"education mama"—is a stereotype based on many examples. And of course, it's not all just for the child. His mother will see herself as a success or failure depending on how he does.

Yoshiko Hanai describes the way Japanese women invest time, money, and energy in their children's education. "They believe this is for their children," she says, "but I feel like they don't know how the children feel. . . . I'm not sure. Sometimes I feel they are doing this only for themselves, [for their] pride: 'My children go to a very good college. My children have this kind of job. . . .' I don't know if it's for the children."

6

Metamorphoses

> . . . The old women, of course, were up to any-
> thing. . . .
>
> —Jun'ichiro Tanizaki, *Some Prefer Nettles*

With so much of their lives sacrificed to the family, one wonders if Japanese women have any identity of their own. Indeed they do, and as they become older, more and more of that real identity comes to the surface. Dramatic changes occur as a woman passes through the stages of unmarried woman, wife and mother, and grandmother.

Young women hide their intelligence behind giggles and silliness, especially around men. They affect a child-like shyness and speak in little girl Minnie Mouse voices which, apparently, young men find appealing. Midori Yamamoto describes teenagers who act as though "they don't want to grow up," and who "like to put all different kinds of cute stickers on their bags."

Debbie Peterson, an American who taught English in Japan, expresses her concern about the frivolity her students exhibited:

> It was very surprising to me to see young high school
> girls in school—that their mannerisms and their voices

are so young, very young in comparison with Americans. It's really kind of frightening. I worry about women who go out into the world and they're trying to earn a living . . . and they're brought up to act and to pretend as if they're completely helpless. It's a really scary thing . . . very frightening.

Debbie may worry too much, for this "immaturity" is often superficial and masks a core of strength and ability. Robert L. Sharp, who writes for the *Japan Times*, was concerned about the young women working at his company. "The impression I had," he says, "was the apparent immaturity of the newly hired young women, whose shyness and apparent lack of any original thought was underlined by their attraction to teenybopper accessories, such as Patty and Jimmy bags, Little Twinstars brooches, and 1950s-style bobbysocks, all accentuated by a sweet little high-pitched voice."[1]

When his daughter found a summer job through a special program at a Japanese company, though, he learned that his initial impression was misleading:

> At age 14, my daughter appeared far more mature than the 21-year-old women in my company, in clothing, range of interests and general poise. . . . While more mature in some aspects, especially externally, my daughter found her young female Japanese coworkers had the capacity to put in hard and long hours, paying close attention to detail and quality of work. In struggling to keep up, my daughter learned there was another kind of maturity she had not completely mastered.[2]

When a girl marries, that childish veneer soon rubs off to reveal a little more of the woman's true self. As wives and mothers, Japanese women rule husbands, children, kitchen, and finances with an iron hand.

As women grow older, they change again, at least externally. "At 50," says Leila Philip, "it is as if another

veil drops, revealing the solid steel of the *obaasan* [grandmother]. . . ."[3]

The golden years are the time of life to rise above unwritten laws for females and to take on a few of those attributes males enjoy. As the anthropologist Takie Sugiyama Lebra notes, having accumulated "social capital," an elderly woman "may assume leadership in the public domain," even though that leadership may be less visible than it would be for a man.[4] An elderly woman may be revered as the "village sage," giving financial, as well as personal advice, as Robert J. Marra describes.[5]

Knowing that their age alone will merit respect, women, especially rural women, no longer feel obliged to pay lip service to female subservience and enjoy what Philip calls "bawdy freedom." Preferring their own female company, "they are outspoken and frank."[6]

It's very much in character that, as *Newsweek* reported, when the prime minister visited earthquake-shattered Kobe to encourage residents to "cheer up and fight the hardship," it was an elderly woman who countered, "That's easy to say. What we need is some action."[7]

7

Looking Back

Two things become strong after the war—stockings and women.

—Common Japanese saying

It's frequently said that there is a big difference between today's generation and that born before World War II. Women today speak of the freedom and opportunities available to the younger generation, but even before the war, although options were limited, women often occupied a place of responsibility and had considerable power within the structure. The strong Japanese woman is nothing new.

In interviews with women who grew up in the prewar era, researchers have found that all took pride in being hard workers. They endured whatever life sent them with the stoicism admired in Japanese society. And when their husbands went off to war, they took up their places on the home front. They exhibited "tremendous strength." "Beyond the passive endurance women were socialized to anticipate," says the researcher Anne O. Freed, they "displayed courage and chose their own path."[1]

Their strength and resilience helped them survive the difficult war and postwar years. With their husbands

away, or remaining single because of the lack of eligible bachelors, many of the women were self-reliant and independent, and several advised younger women to develop ways to stand on their own two feet.

Japanese women here often cited their own mothers as a source of inspiration. They encouraged their daughters to accomplish what they of a previous generation had not been able to.

Yukiko Matsumoto is still bitter when she remembers how her father wanted her to be a traditional wife and mother. Yukiko was a gifted student in a nontraditional field for women, economics, and yet her father was determined to place every obstacle in her path. "I wanted to be different," she says, "I wanted to be something." It was thanks to her mother that she achieved her goals:

> She always encouraged me. My mother is a wonderful person. She was a very capable person. She never realized her potential. . . .

> My mother was very understanding. She was very warm; she was the pillar of the family. . . . I think of my various ages, and my mother really understood me. She encouraged me but my father discouraged me from doing anything. My mother encouraged me to do anything, in school, and high school and college. She would say, "Think, think very carefully about what you want to do, and tell me what you think," and I always did. . . . My father would never support me, but my mother would say, "You will find another way."

> My mother encouraged me, and I think she expected me to have what she wanted to have. She was a discouraged woman, too. She was very, very capable, more so than I am, but she couldn't do anything because of the times.

Yukiko did eventually attain success in her chosen field, and to her surprise, her father took pride in her achievements.

Yoko Saito, the wife of a graduate student in a Midwestern university and mother of an eight-month-old baby girl, recalls that she, too, was encouraged by her mother, even though her father objected to her plans to work in a research laboratory.

"When I told my father I wanted to work at the university, he said, 'No, you don't need to. If you were a boy, you could work at the university, but you are a daughter. You're just a woman, so you don't need to.' But my mother said, 'If you want to, if you have the will, you can do anything you want, because *I* can't.'"

Yoko looks pensively at the baby on her lap, as if wondering what *her* future will be like, and repeats softly, "My mother said, '*I* can't.'"

In spite of the barriers, several of the mothers of those I met with *had* held outside jobs, through necessity, if not by choice. They worked in the family businesses, or as a beautician, or giving flower-arranging lessons, or in the case of one student's mother, as a psychologist. One grandmother had held two jobs, since her husband was "lazy," working in a supermarket as well as doing alterations. When Yukiko's father became very ill during the war, her mother worked as a translator and executive secretary in charge of two subordinates. Yoko's mother's ambitions, however, were superseded by duty when, in her early twenties, she became surrogate mother to her husband's six orphaned younger siblings.

There is evidence that centuries ago women had more control over their lives than did those of Yoko's mother's generation. Hundreds of years before World War II the *ie*, or extended family system, was the primary economic unit, and one in which women played an essential role.

In the *ie*, established as far back as the eleventh or twelfth century, in all classes, from the aristocracy down through the peasantry, the official wife or the highest-ranking woman was in charge of household affairs.

Although the male household leader represented the *ie* to the outside world, it was the female head who held

the real power within it, for she had exclusive control over the distribution of rice. In the villages of pre-Meiji Japan upon retirement at the age of forty the mother-in-law would transmit her rice ladle to the daughter-in-law, symbolizing transfer of this power.

Rice was more than an important staple. With an almost religious significance, it was used as currency in a premonetary society. Taxes were paid in rice and samurai received their stipends in rice. The sociologist Chizuko Ueno points out that "control over rice meant control over the domestic economy, and it was in the hands of the female household head."[2]

Reforms of the Meiji period in the late nineteenth century brought "samuraization" to all of Japan—standards of the upper class were then applied to the whole country, not always to the benefit of women. Now that the traditional class distinctions no longer officially existed, more liberal practices that had been in effect were replaced by restrictions that previously had applied only to the samurai class. Before the Meiji period, it was not uncommon for women in rural areas to become heads of households, and in at least one case, women voted in village elections.[3]

The life of the samurai was the forerunner for a lifestyle many "salarymen" lead today. Samurai would commute to the lord's headquarters every day, returning in the evening much as salarymen go off to the office. Like businessmen transferred abroad, samurai would accompany their lord to the capital during his required alternate years away from home. A rise in the class of wage earners, replacing the old self-employed merchant peasant class, meant even further imposition of the samurai system. Today it's the company that has replaced the extended family and the village of an earlier time.

It was not until the Meiji period in the late nineteenth century, when Japan was more deeply influenced by the West, that mothers became responsible for educating their children. And it was not until the Taishō

period (1912–26) that "the image of the loving mother" appeared.[4]

In the earlier, Tokugawa era the role of mother was not the exclusive role of women, as men were closely involved with the upbringing of children. Nor was motherhood the most important of the female roles. Women's contributions to the economic survival of the *ie* were just as important as their reproductive and child-rearing abilities.

The years before and during World War II further influenced the general perception of women. With their men away, women had to assume the role of father as well as mother. The government encouraged a strengthening of the family through publications stressing how important the mother was in maintaining the family.

The idealization of mothers today is due in large part to this importance given them in wartime Japan. A warm and loving mother, and a prolific one, was what was needed for the war effort. Japan's militant leaders of the 1930s also promoted large families in order to create future soldiers for Japan's military adventures.

After the war fathers lost more status in the family as, once again, they were away from home, this time at the office. Japan's rapid economic growth meant that the breadwinner spent longer and longer hours at work to meet the country's economic demands.

Looking back to before the modern period, we can see that for centuries women who were not of the samurai class held great responsibility beyond motherhood. Ironically, it was the applying of the samurai model to all of society that eventually resulted in today's situation. Absentee fathers, now loyal to the company rather than to the daimyo, have forfeited responsibility in favor of their wives.

III

Women in Japan: The Public Sphere

In the beginning, women were the sun. The sun was shining, and we were truly human beings. Now we are the moon, pale-faced like sick people, shining only as the reflection of others. We must take back our hidden sun. We must find our hidden talents.

—Fusae Ichikawa, 1911

8

An Overview

While women enjoy a great deal of autonomy and respect in the private sphere, it is, of course, in the public sphere that they meet with obstacles. In fact, most women face overt discrimination for the first time when they leave school to enter the work force, but it is discrimination at its most blatant. Japan continues to be one of the worst countries in the world in offering equal employment opportunities to men and women.[1]

It is to the credit of Japanese women that, in spite of numerous roadblocks, they have progressed at all in the outside world, as happened especially in the booming 1980s.

Today more women work in Japan than in several other industrialized countries. Thirty-eight percent of Japan's work force is female, compared with 41 percent in the United States.[2] For the first time in history, more than half of Japan's women available for employment have entered the job ranks, some 26 million strong, a figure that also includes part-time workers. This proportion is comparable to those in Europe and America.

We have to look at more than numbers, though. The conditions of such employment paint a less than rosy picture. Because of the kinds of jobs women usually perform, there is a wide gap between the earnings of women and those of men: women earn 53 percent of the figure

for men.[3] *In the United States women earn 74.7 cents for every dollar earned by men.*[4]

Women's jobs, in general, are not those for which higher education is required; the plum jobs still go to the men. Beginning with education, as we've seen, parents invest more in their sons than in their daughters, because they expect greater returns. About three times as many men as women attend four-year colleges, whereas almost all students at junior colleges are female.

Attending a four-year college can even be a disadvantage for a woman since many Japanese companies won't hire any female university graduates at all. Those from the two-year schools are considered more desirable employees because they are less demanding, doing less skilled work for lower pay.[5]

Chiaki Shindo, now living in America, remembers that even though she had a degree in economics from renowned Keio University, she was hired as an "Office Lady," the typical menial clerking job for women, while her fellow male graduates were snapped up for the good jobs.

Girls are still steered away from the traditional male fields. Debbie Peterson reports about teaching in an all-girls' high school in Japan:

> That was really frustrating for me because I saw an enormous potential in some of the girls there, and it was just so stifled. There was no one there saying, "You *can* be anything you want, or do anything you want." Most of them were told to try art, literature, stick to home ec, stay in food science in our college, which was attached to our high school—but no real push to strive to be something special. And you saw the boredom written all over their faces. They sat there falling asleep. . . . They're told from the very beginning that women are weaker at science and math.

In the United States, too, young women get short-changed. A Department of Education study showed that,

even when math scores were the same, twice as many men as women went on to study physics.

Teachers pay much more attention to the boys in the classroom than they do to the girls. Boys are the ones who raise their hands and clamor for attention, while girls tend to be docile and "well-behaved," to their ultimate detriment; it's the boys who end up scoring higher on standardized tests. Female students are well aware of such gender discrimination, which undermines their self-esteem. As in Japan, they are discouraged from pursuing math and science. Only about 12 percent of America's scientists and engineers are women.[6]

When young women leave school and look for a job, they are seldom hired at the large companies that offer the much-heralded benefits of work in Japan. Ninety percent of Japanese companies have less than three hundred workers, and it is these smaller companies that employ 80 percent of Japanese women, many of whom work part-time.[7] Small businesses are more flexible, and since they find it difficult to attract capable male employees, ambitious young women often find their niche there.

Of course, such small businesses are not part of the lifetime employment picture. What we think of as the typical Japanese work life, security with a company that offers steady raises and bonuses based on seniority, is typical only for men. Women are excluded from the system.

In America, too, it is the small- and medium-size companies that offer more alternatives. Consequently many American women executives have switched to smaller firms.

Foreign companies, again usually the smaller or medium-size companies, are also thought to offer greater opportunities for women. Because such companies cannot offer the benefits of large Japanese corporations, they, too, aren't able to attract the top male recruits. Since it's possible for bright young women to advance there, it's not uncommon to find Japanese

women in the management of companies that are head-quartered abroad.

Since around 1965 graphs of women's employment in Japan have shown what is called an M curve. Young women work until the first child is born, leave work to focus on child care, and then return to the work force when that child enters school. In fact, this M of female employment is the largest in the industrial world.

Those who reenter the working world find that they have missed out on the benefits of continuous employment, even if they should be lucky enough to work at a large company. In Japan, equal pay for equal work is not a concept. It's seniority that counts and that is essential for raises and promotions.

What is more, as in America with its "old boy networks," male employees typically look to mentors for advancement. In Japanese hierarchy with the Confucian importance of personal ties, those in a higher position help those below them, but again, such junior-senior relations do not exist for women.

Many of the women returning to work opt for part-time jobs; some 36 percent of female employees are part-time, temporary, or contract workers.[8] There are tax incentives that promote part-time work over full-time. Those earning less than the equivalent of about $10,000 a year pay no tax on this income and can still be claimed as dependents.

These part-time jobs will be no better than the ones the returnees held before they left to have their children—"frying burgers at McDonald's, ringing up groceries at supermarkets, or marching door-to-door selling cosmetics," as Deborah Fallows says.[9]

The term "part-time" can be a misnomer, since almost identical jobs may carry different titles, with the "part-timer" of course receiving less pay. Such women, perhaps numbering one million, may work forty hours a week, doing the same work and with the same qualifications as the "full-timers," but at wages that average 30

percent less and without the fringe benefits the other workers enjoy. Part-time workers, 70 percent of whom are women, are also considered dispensable when the economy goes down; a slang word for part-timers is "throwaways."[10]

In America women make up 66 percent of "contingency" labor, also called "disposable" workers. As in Japan, these 35 million or so part-timers, temps, and contract workers get no benefits, have no chance of advancement, and get less pay—part-timers average about 40 percent less than full-timers.[11]

When hard times strike in Japan, women are "the last in and the first to go," says Dr. Elenore A. Koch.

Such part-timers, temps, and contract workers act as a cushion for the Japanese economy. By exploiting this large body of dispensable, low-paid female workers, employers can offer more job security for a core body of male employees.

A case in point might be the Nomura Securities Company, Japan's largest brokerage house, whose massive layoffs in 1992 were aimed largely at women. Many other companies, too, have been eliminating the jobs of their female employees and refusing to hire new ones.

Although nontraditional jobs are increasing, clerical jobs are typical and employ about one-third of Japan's female work force.

In the United States, too, the largest percentage of employed women—over a fourth—do some sort of clerical work.[12] *Betty Friedan laments that "the overwhelming majority of women are still crowded into the poorly paid service and clerical jobs traditionally reserved for females."*[13]

A large "informal sector" of working women also exists. These are the women involved with such things as giving lessons in flower arranging and the tea ceremony, tutoring, or helping with a family business. Women labor unnoticed on farms and in fishing villages, or in the many "Mom and Pop" corner stores. They may

not be garnering success in "JAPAN INC." but their skills have enabled them to successfully operate many a small business, especially in the service industry.

A growing number of women are becoming entrepreneurs, given the stress that many companies place on seniority and overtime. In the late 1980s five out of six new businesses in Japan were started by women.[14]

In America, too, the fastest-growing group of small businesses are those owned by women.[15] *Over a quarter of businesses in the United States are now female-owned.*[16]

As for the family farm, it's become a mostly female responsibility, since men now commute to urban jobs or work seasonally. About 0.6 percent of the female work force in Japan is in agriculture and related activities, the same figure as for the United States.[17]

Demographics play a large part in women's employment statistics. A low birth rate and a longer life span are factors. Now when those average 1.46 children enter school, their mothers have many more years stretching out before them to devote to work activities. The greatest increase in the figures for working women is in the 35–64 age group.[18]

9

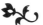

The Young Single Woman

"OLs"—"Office Ladies"—is a term that describes one-third of Japan's female work force, and one that denotes doing menial chores and pouring endless cups of tea. Smiling, bowing, looking smart in their company uniforms, they spend the years between graduation and marriage providing a decorative touch to the office.

Living at home with no household expenses, Japan's young women are free to travel and spend their spare time shopping, meeting friends, and betting at the races.

Dr. Elenore A. Koch describes the life of young single females:

> They live at home, they get these jobs, and the parents permit them, with the affluence of the home, to buy the most gorgeous clothes! They and their female friends go on all those holidays to Europe and to Hong Kong and all. They go on all those trips. They can spend all their money.

Although every Japanese woman wants to get married eventually, she says, the younger ones are in no hurry. A government survey in 1992 showed that employment of women of ages twenty-five to thirty had increased almost ninefold since the previous study five years before, an

increase attributed to the fact that women are delaying their exit by remaining single.[1]

Today it's the men who seem more eager to marry. Prospective husbands in the rural areas are having an especially hard time finding spouses, to the point that an increasing number are choosing brides from other Asian countries.

Apparently in Japan, in the words of the popular song, "girls just want to have fun." My Japanese friends agree that the younger generation is out for a good time, and the statistics bear this out. As reasons for employment, 57 percent of women in their twenties stated that they work just to have money for fun, 54 percent want to have money to save, and 38 percent work in order to make friends or for other reasons.[2]

More women can support themselves today, but that doesn't mean that they have a long-term work goal in mind. They're not eager to devote their whole lives to running the rat race that they see their fellow male workers embarked on.

Once young women do marry, they have fewer children than previous generations did. That low birth rate of less than one and a half children per couple has Japan's government worried enough to propose "baby bonuses" to promote larger families.

The birth rate in the United States in 1990, in contrast, is 1.8 children per family.

10

The Working Mother

The concern over Japan's low birth rate has prompted the government to pass a law granting up to twelve months of maternal or *paternal* leave. However, less than a third of the companies actually offer such child care leave. The government has also instituted a program to help companies provide nurseries to offer around-the-clock care. There is doubt, however, that such a plan would work, given the expense of such arrangements. Japan has a great number of day-care facilities—more than any industrialized country—but the fact that they usually close at 5:00 P.M. or 6:00 P.M. precludes their use by mothers with serious careers. So child care continues to be a major problem.

Nor are American women likely to find satisfactory child care. A recent study concluded that "the care provided by most American child-care centers is so poor that it threatens children's intellectual and emotional development," a New York Times *article reported.*[1]

In spite of the problems, now that women have fewer children to take care of and more time on their hands due to the availability of household appliances, the largest group of working women are married. Women with children are the fastest-growing segment of the work force: "Fifty percent of all working women and 22.2 percent of the labor force as a whole."[2]

HIGHLINE COLLEGE LIBRARY

As always, the children come first, so if a mother feels that her job is having a negative effect on her child's life, she will leave work to take care of the child's problem.

Balanced with this, though, is the question of whether there are child-related expenses that warrant the extra responsibility, to pay for *juku*, an after-school tutoring school, for example. Many parents feel such extra schooling is worth it to give their children a competitive edge in all-important entrance exams. (Other reasons for working might be to earn money for retirement or to cover the cost of high-priced real estate.)

Dr. Elenore A. Koch describes some of the expenses that a child's education can entail in her area:

> After-school schools are about $40 an hour, and the children start at about the fourth grade, and they go five or six hours a week, plus they have to have extra training, plus they go to Saturday school. Then the expense of the private [elementary] schools plus the expense of the private high schools, the expense of the uniforms—the uniforms are beautiful in Japan, but they are so expensive! You're talking about $150 for one set, and the child might need ten different sets. Girls need a spring set, summer set, a winter set. Boys, too—they need sets for when they go out, they need sets for gym, and that includes the socks monogrammed, the underwear monogrammed. . . .

Mothers also work to buy the little extras for their children. According to Marilyn Inoue, if you're a working mother, your income

> would go for your child's flute lessons, or maybe saving for a trip, but it would usually go for something for your children, maybe saving for your children's college, or buying your child some extra, you know, that they need for school. That's usually what women work for, that kind of stuff.

And the work is almost always part-time, she recalls: "I did not know any married women who had full-time jobs."

Part-time work, because it can fit in with a child's school schedule, is the type most women prefer. As Marilyn notes, such work is usually "in a grocery store, or coffee shop, or restaurant, or cleaning, or as a crossing guard—those kinds of things." Again, being very practical, Japanese women who return to work look for a convenient location and flexible hours.

Work at home, *naishoku*, is another option, but this is at the lowest level and of the very lowest status. It's monotonous work finishing partly manufactured products or textiles.

At any rate, mothers who work outside the home in Japan face tremendous pressure. No matter what the outside job may be, they are still responsible for the care of the house, with little or no help from their spouses. One survey showed that when both spouses work, the men devote only 8 minutes a day to "home" work, compared with their wives' 3½ hours.[3] Other studies revealed that Japanese men spend *1 minute* a day on child care[4] and 11 minutes a day on household chores, versus American men's 108 minutes.[5]

Not that American working women have it much better when it comes to housework, even women at the highest levels. Sen. Diane Feinstein says that "every career woman with a family does the wash, the laundry, scrubs floors, cleans the bathrooms, changes the beds."[6]

Emotional strain is also a problem. As in America, where, says one working mother, "women of my generation live with guilt," almost all working mothers in Japan feel guilty. To add to this burden, an increase in crime is blamed for the fact that more and more women are working and leaving their children alone or with caregivers.

11

The Career Woman

Many mothers may choose to work, but having a real career means having to forgo family life, since the Japanese way of thinking is that you must give all your loyalty to one group and to that group alone.

Not only must a woman work "four or five times as hard as a man," says Masako Takita, but "she has to choose. The majority of women who have achieved high positions," she says, "like congressmen even, or executive positions in a company, are single women." Takako Doi, who attained the highest position in the Japanese government ever held by a female, that of Speaker of the House, is unmarried and childless, she notes. Only three of Japan's twenty top female diplomats are married.[1]

In the United States, on the other hand, a survey of top women executives showed that 60 percent were married and almost six out of ten had children.[2] However, as companies downsize and more time is required of remaining managers, many women with children are taking less demanding positions or opting out altogether. The consultant Carol Sladek says that if you look at those "on the fast track, you will see women whose children have grown, women who don't have children, women who are not married. You very seldom see women with small children."[3]

Yukiko Matsumoto, the economist, speaks of her professional working days before she had a child:

> We were not the majority, but there are so many won-
> derful women in professions, and so many of them give
> it up to be a mother. So many executives in govern-
> ment offices—they don't have children. Isn't it true
> that many professional women, career women, have
> given up to continue their career? They have sort of
> given up a family.

It takes a lot of support at home for a woman to suc-
ceed at a profession. Most of those professional women
who do have children have mothers or maids who care
for them, and even then, it's not easy. In Japan I spoke
with a few women who balanced motherhood with their
administrative positions at an educational institution. It
is *possible* to combine both, they said, but they empha-
sized that it is "very, very difficult," even though they
had family or close friends to help with child care.

Marilyn Inoue has known a few Japanese career
women, and they seem to be a certain type: They "are
often an only or oldest daughter; the parents are dead;
they have no other ties; for whatever reason they haven't
married." To have a successful career, not only in
Japan, but in America as well, she thinks, "you still
have to give up the whole family thing."

Recruitment

Should a woman make the decision to pursue a
career, the first hurdle comes when she seeks employ-
ment. Even in the boom years of the 1980s, many ads
still stated that males only were expected to apply.
Another common way of excluding women has been to
have different days for men and women to apply. If not
enough males are available to fill the jobs, then the com-
pany will hire females.

Since the bursting of the 1980s economic bubble,
young women are having a harder time than ever finding
jobs. Thousands of graduates have spent countless, and
fruitless, hours looking for work.

Why are companies so reluctant to hire women? Many of those that admit that they only hire men for technical positions claim that women usually do not have the technical training or skills that the company needs. Companies are also reluctant to invest in women who will leave after a few years.[4]

There is some justification for the reluctance of firms to hire women since their short working life doesn't merit the expense of recruiting and hiring them, according to the economist Alice Lam. In one study some women replied that their employer showed a greater willingness to appoint women to senior positions than in the past, but too often the women tended to resign soon after accepting such promotions.[5] As Millie R. Creighton reports, the demands of the job are considered too high a price to pay, especially—in a kind of "chicken and egg" situation—when women have no assurance that their sacrifice will pay off.[6]

There's another ploy company recruiters use to discourage females from pursuing career employment. They will ask a prospective hiree if she would be willing to be transferred if the company so requested—say, to Teheran. When she says no, she is automatically eliminated from the competition. According to Mariko Yoshino,

> When they hire people the company asks the individual whether they can go to those politically dangerous places in the world, and men, usually, they say yes, because building their careers is very important, but women—not many women say yes, but that's the reason why the company wants to ask! They intentionally keep the women out.

Executives

If a woman does aspire to a career, Fumiko Yamaguchi agrees with others that she has to work much harder than a man: "The man can rise so easily compared with the woman. If a woman wants to work at a

big company she has to work so hard, harder than the man,"—perhaps four or five times harder, as Masako Takita has said.

In 1987 Japan enacted an Equal Opportunity Employment Law (more about this later). One response to this legislation has been a two-track employment system in some large companies: the "integrated" or career path (*sōgōshoku*) and the "general" (*ippan*) path.

The general path entails the kind of less demanding responsibilities that Japanese women have traditionally assumed, while the integrated path means that the employee agrees to comply with all of the demands placed on just male employees in the past, including transfers and overtime. Masako Owada, the new crown princess, has been a highly visible example of a *sōgōshoku* woman.

One problem is that once companies get *sōgōshoku* women, they don't know what to do with them. Midori Yamamoto says that too often career-track women, like the "OLs" and other women before them, are dissatisfied working at large companies, and so

> they go somewhere else, maybe a smaller-scale company, where they are maybe more appreciated, because a lot of time those university graduate females—integrated—go to work for those big companies and their bosses don't really know how to use them, because it's really a new experience for them, too. They really do not know how to appreciate their abilities, and eventually the university graduate girls get kind of discouraged. They come to work with a lot of hope that they will be able to contribute to the company, and then their bosses don't know how to use them, so they will get frustrated. . . . Of course there's the jealousy part from the "general," too . . . so there's a kind of isolated feeling, so they look for some other, smaller company that will appreciate them more and they can really show what they can do.

Resentment from women in the general track that Midori mentions is a common problem that these pio-

neers must handle. Even though the *sōgōshoku* women may have to face up to all of the responsibilities that are traditionally male, if they're not willing to perform all the little menial chores that women traditionally do, then they incur the dislike of those in the general track.

Yukiko Matsumoto, who was one of the first women researchers at her institution and "wanted to compete with men," says she "had to pay a lot to cope with" the other women at the institution, because

> those women, the secretaries, the OLs, they thought I was arrogant. I wasn't—I was just myself. I was in with the men researchers. That was natural for me. I worked for it. The OLs really resented it, I have to say. Those women wouldn't handle the documents, the papers—expedite them—and so in one month I learned that I had to be very nice to those OLs or else my job wouldn't get accomplished. So I tried very hard to act like a very nice person to those women, and to say nice things to them, and I found out later that they were also very, very wonderful, and I started to make friends with them.

Dr. Elenore A. Koch is not very optimistic about the *sōgōshoku* prospects. She describes the unsatisfactory experience of a *sōgōshoku* acquaintance:

> She's treated like a man, but she's treated at the bottom. . . . They sent her to the United States for four months. They never sent women, but for four months' assignment, because they were opening a plant, they sent her to do the P.R. and do all the bowing and, you know, get the blueribbon panel and take care of the travel for all the people. Then she came back and she lost her job. I mean they took her job and gave it to somebody else. I said, "Are you in the same department?" and she said, "No. Before I left I specifically said that I must have my job. I want that job in computers." And now they put her someplace else that is totally a no-brainer. So the Japanese would have a very difficult time, very. American women had gravely

difficult times in the '70s. I can remember, I could tell you stories . . . and the Japanese woman would have a much more severe time.

Just as there are complaints from nominally part-time workers that they are working full-time in all but name and benefits, there are also complaints from so-called general track women who say they are doing all the work of *sōgōshoku* employees but are discriminated against solely because they cannot commit to transfers.

Whether or not discrimination exists, the fact is that there are very few women managers—about 4 percent according to government reports. Here are some reasons why companies say they have few or no female managers: According to about half, women lack the necessary skill, knowledge, or "sense of professionalism." Almost a third say that women leave work before reaching management level. Women don't want to be managers, they claim, and they cannot accept responsibility because they are also responsible for their families. What's more, women can't meet company requirements for overtime work and "midnight duties."[7]

In the United States, white males continue to hold 90 percent of the top management jobs. Nevertheless, there are more than ten times as many women in all administrative positions as there are in Japan.

Having a career in Japan entails sacrifice. For those willing to make the sacrifice, though, there are those like the leading sociologist Chie Nakane who say that, once launched on a career, a woman will find little discrimination. Nakane claims that in Japan "sex consciousness has never been as strong as it is among the Americans."[8]

Career Women in the United States

In order to be able to make a comparison with the situation of women executives in Japan, let's take a closer look at the status of executive women in America.

According to a Department of Labor Report, women make up 37 percent of the work force, but only 6.6 percent reach the executive level of corporate management. Only five women, or 1 percent, are CEOs of Fortune 500 companies.

In America most women managers feel that men are better treated. They feel that they'd be higher up the executive ladder if they were men, and that they've had to work harder and be smarter than men to reach the same goals.

Although women may hold management positions, they are often confined to the lower ranks of management or to certain fields. They predominate in the "people" areas in companies, in departments like labor relations, personnel, and public relations. There are disproportionate numbers, as in Japan, in the "helping" businesses related to cleaning, health, food services, and the like.[9]

In spite of the 1963 Equal Pay Act, here's how the median wages for men and women compared in 1996 based on Bureau of Labor Statistics:*

Education	Men	Women
Graduate School	$53,300	$40,768
Bachelor's	41,340	31,616
High School	26,832	18,980

American women may be ahead of Japanese women, but they are still very far behind men in this country.

Language

Consider the language problems American women face in the business world. Deborah Tannen and others have pointed out that women use language to make con-

* United States, *"Labor Force Statistics from the Current Population Survey," January 24, 1997.* http://stats.bls.gov/news.release/wkyeng.t08.htm> (31 March 1997).

nections, while men use it to establish hierarchy. The language patterns that women use work toward making them liked, rather than respected. American women have to run a fine line between being thought feminine while still being authoritative.

The writer Kumiko Makihara reports the same problem in Japan: "A woman who speaks too openly and directly in business meetings is too aggressive; but if she just sits silently, the men will wonder why she's there in the first place."[10]

In Japan's vertical society, women are at an even greater disadvantage, because politeness demands that women conform to hierarchical distinctions, that they use more honorifics, more humble language than their male counterparts. "Humble" is hardly the impression a striving professional wants to impart to establish authority in an office situation.

Because men's and women's language is so different, "talking like a man" is even more difficult than it would be in America. Kittredge Cherry notes that even choosing which word to use for "I" means picking a level on the social scale:

> To pick one is to identify oneself by gender, age, and level of respect felt toward the listener. Those used primarily by females include *atashi, atakushi,* and *atai,* while men generally say *boku, ore,* and *washi,* although both can use *watakushi.*
>
> The choice of an "I" is one of the hallmarks differentiating feminine language . . . from the neutral and masculine ways of speaking Japanese. Women's speech differs in vocabulary, intonation, and its more frequent use of polite forms and gentle-sounding particles at the end of the sentence.[11]

Masako Takita, the energetic wife of a "salaryman" in Indiana, runs her own consulting business at home. When she's on an assignment in Japan, she may go out

with the boys in the evening, but she continues to use women's language.

Yukiko Matsumoto, whose colleagues at her research institute were all male, chose her speaking style to fit the situation: "Outside of work I had to use good, respectful language. But among friends I used ordinary language, always equal," which was probably unusual. While still a teenager she had learned to cherish the advantage of women's language, though, because it "can express a richer and more colorful feeling. I like that. . . . I started to talk with my girlfriends about how women can express relationships better in women's language." She believes that "in literature and culture, the woman's world is so wonderful."

Women in politics have this same language dilemma. Nobuko Yotsuya, who was elected the first female vice chairman of the Tokyo Metropolitan Assembly, can't be "one of the boys" and use the familiar speech style that is customary for the male members of the assembly.

But Takako Doi, who became the highest-ranking woman in the Japanese government, is one who doesn't follow expected feminine behavior. Her voice is deep, she uses "masculine" verbs, and she drops the honorifics. What's more, she's known to look her listener in the eye.

Other women, too, have chosen to deliberately adopt men's language. Some engineering students, for example, have opted for this way of speaking. But then there's the danger of being considered too "weird" for Japanese society. Marilyn Inoue describes a student of hers who

> talked like a boy, and everybody thought she was weird, but she was a liberated woman, and that was her take on that. She was very aggressive—I'm sure she probably got beat over the head, poor thing—but she was very aggressive, and she wasn't mannish, or tomboy, or lesbian, or anything like that, although people implied that. But I know from talking to her

that that was her take on how we were going to have equality, that men and women were going to have to talk the same: "If I want to be accepted in a man's world, I'm going to use man's talk," so she didn't use that polite, around-the-bush talk, she said *boku*, and "I want this," which is what men do.

Marilyn thinks on the whole, though, that the use of male and female language is not that different from the language used in America, where women are taught to say "Would you please?" or "Could you possibly?" or "Won't you?" "Don't you?" or "How about? . . ." and where the tone of voice is different.

Sexual Harassment

Sexual harassment is another problem that bedevils both Japanese and American women, and this, too, is worse in Japan than in America. In a recent poll 95 percent of women contacted said they had been harassed on trains.[12]

It's prevalent in the workplace, too, says Dr. Elenore A. Koch. The women, she says

> just bow their heads when [the men] tell a gross sexual joke or say something that's very wrong, . . . See, that's that strength of the Japanese woman. They will persevere and they will endure, and they just bow their heads, and they don't lose any of their dignity or honor. . . .

Debbie Peterson, who recently returned from teaching English in Japan, states that "there are still a lot of sexually inappropriate jokes that you hear when you're in groups with men included."

Debbie, a tall attractive blond in her twenties, admits that perhaps her appearance alone was enough to cause her to be noticed. The very fact that she stood out in the crowd might have been responsible for some of the

unwelcome attention, but her Japanese colleagues also complained of harassment. "*You* can leave," they told her, "but *we* have to stay here and put up with it."

Japanese women may be tired of "putting up with it." In a first for Japanese courts, a female magazine editor was awarded $12,500 because she was forced to quit when her boss spread rumors that she was sexually promiscuous. In the past, says Masaomi Kaneko, the author of two books on sexual harassment, "when problems arose, many corporations tried to solve them by having the women quit. But now they can't."[13]

Part of the problem is due to male ignorance now that women are making inroads in a man's world. Just as women's bosses don't know quite what to do with those on the new career track, they also do not know what is appropriate behavior in their presence. Many older men know just three types of women: wives, women with supportive jobs, and the bar hostess types.[14]

Women in career positions in America, too, are not unfamiliar with sexual harassment. More than half of the top-level female executives who participated in a survey said they had experienced sexual harassment, "although most ignored it or confronted the harasser privately."[15]

For a picture of how women in Japan—and in America—are faring in the professions and in the political sphere, see appendexes A and B.

It comes as no surprise that there are many roadblocks in the way of a woman's career in Japan. What *is* surprising is that the struggle to tear down these barriers is not new.

12

Modern Times

Men are different from women in sex, but there is
no difference between them in status or in value.

—Yukichi Fukuzawa, 1898

When we look back through history in the West and
in Japan, we find that Japanese and American women
have more in common than we might at first think.
Beginning in the nineteenth century, Japan has had its
own ardent supporters of women's rights. There are
many parallels as women on both sides of the world
have sought equality.

The modern era in Japan began when, after being
closed to the world for some 250 years, it once again
opened its doors to the West in the nineteenth century.
Japanese leaders were eager to learn from up-to-date
America, prospering now that the Civil War was behind it.

The Prewar Years

Education

With the installation of the Meiji government in the
1860s, reform swept through Japan. Empress Haruko
encouraged women to participate in education and in

social welfare projects. At that time Christian missionaries were allowed to enter Japan, where they established schools that offered equal education for both sexes.

The late 1800s saw the publishing of many books on feminism and women's education. There was Koka Doi's *Great Civilized Learning for Women* in 1896, and in 1898 "the Great Enlightener" Yukichi Fukuzawa wrote the "New Great Learning for Women." It refuted the classic "Great Learning for Women," which had admonished women to obey their husbands. Now women were to be considered equal to men.[1]

Arinori Mori, educated in England and in the United States, became minister of education in 1885 and sought the advice of American educators on improving educational standards for women. This led to the founding of the Women's Normal School, today's Ochanomizu University.

But there was a reaction, a kind of backlash, against so much copying of Western ways. Mori was assassinated by an ultranationalist in 1889, and the mood of the country soon reverted to a more traditional, Confucianist style.

While Meiji reformers were working on improving conditions for women in Japan, reformers in America were also promoting higher education for women. Oberlin College having led the way by including women in its student body as early as 1833, the Eastern women's colleges were founded in the 1870s and 1880s. Many in America, however, still believed that education above a certain level was harmful to women. In the 1860s, most people still agreed with Jean-Jacques Rousseau that "the whole education of women ought to be relative to men." They should devote their lives to making the men in their family happy.[2]

Early Industrialization

While still keeping its national spirit, Japan was determined to modernize and raced to catch up with the West. Industrialization was promoted at the expense of

rural welfare, and on whom did industrialization depend? The young female factory workers, mostly farm girls whose impoverished families signed long contracts for them at low wages. Often the families were paid a lump sum in advance, and the girls were obliged to work off the payment.

Conditions in the textile mills where most girls worked were unhealthy—fourteen-hour workdays, poor food, for which the worker was charged, inadequate housing, often brutal supervisors, and lint-filled air that promoted tuberculosis. Many of the girls were quite young—in 1897 13 percent of cotton mill workers were younger than fourteen, and some were younger than eleven.[3]

America's industries at the time were very similar to those in Japan. In 1890 most of the approximately four million American women working outside the home settled for low wages and poor working conditions, perhaps "packed like sardines in a box."[4] Child labor was common here, too, and work was dangerous. In those pre-OSHA days,

> *Those who worked as feather-sorters, fur-workers, cotton-sorters, or with other dust-laden materials were prone to lung and bronchial diseases. . . . Match-workers often had their jaws eaten away by phosphorus. And button and pin workers regularly suffered jammed and caught fingers which were treated at the worker's own expense after the first three injuries. . . .[5]*

In America, as well as in Japan, conditions cried out for reform. The legendary Mary Harris "Mother" Jones rallied workers from New Jersey to Colorado to protest conditions. The labor agitator Elizabeth Gurley Flynn cast her lot with the militant labor unions and with the socialist movement with which they were allied. Ultimately for working women the union movement and socialism were a god that failed. Men may have given lip service to equality for women, but they did nothing to help.

Emma Goldman, "Red Emma," "the Anarchist Queen," "the most dangerous woman in America"[6] also followed the ultraleftist, radical path. Her numerous speeches and publications made her an international figure.

When the prominent anarchist Shūsui Kotoku was brought to trial in Japan, she lectured in support of him and the other defendants. Her publications would greatly influence women reformers in Japan.

Having received training in prison as a nurse, Emma Goldman was also known for her work in birth control with Margaret Sanger, who in turn was an inspiration for women reformers in Japan. Sanger's friendship with Japanese baroness Shizue (Ishimoto) Katō would spearhead the birth control movement in Japan.

Political Rights

Although the Meiji era brought some gains for women, as noted in chapter 7, in other ways they approached the twentieth century worse off than ever, now that samurai-class restrictions were applied to all. One legal provision stated that "cripples and disabled persons and wives cannot undertake any legal action."[7]

Particularly rankling to feminists was the Peace Preservation Law of 1887, enacted in reaction to what had been thought to be the overdemocratization of Japan. It decreed that women were not to engage in political activity of any kind.

It's important to remember, however, that the whole political climate in Japan was very different from that in the United States. Japanese men, too, were disenfranchised for the most part, as voting privileges were based on property ownership. Only 2.6 percent of the male population was able to vote.

Christian groups like the Salvation Army and the Temperance Union worked for the betterment of society, and Japanese women were often inspired by their sisters in the West. Early pioneers like Toshiko Kishida, a Christian convert, and her follower, Hideko Kageyama,

worked for women's rights in the early 1880s. But in Japan, as in America, many women reformers looked to the political left to right their wrongs.

One of the best-known voices to speak in favor of women's rights was that of Haruko "Raicho" Hiratsuka, who founded the Bluestocking Society in 1911 and began publishing its journal in 1913. Originally a literary organization, the society soon took on political overtones, which grew stronger when 20-year-old Noe Itō took over its journal in 1915.

Itō was a free spirit who sought the independence of women in every way, including in affairs of the heart. She became involved with a leading anarchist, Sakae Ōsugi, who didn't let his marriage deter him from his relationship with Itō, as well as with another social activist at the same time. Like other radicals of the time, Noe Itō was most influenced by none other than Emma Goldman. And like others who followed the anarchist path, Itō met a violent death, murdered by the military police.

Sugako Kanno was another who sought political change through socialism and, later, through anarchism. She was among those sentenced to death with Shūsui Kotoku, whose trial for attempting to assassinate the emperor commanded Emma Goldman's attention in the United States. It is said that Kanno, in fact, was chiefly responsible for holding the terrorist group together, although some say the charges against her were falsified. When her death sentence was commuted, she tore up the commutation and hanged herself.

She, too, had had many affairs with men. The "liberated" life-style of women like Kanno and Itō made it all too easy for antifeminists to dismiss their work as "the ravings of loose, immoral women."[8]

The assassination attempt set back the cause of universal male suffrage, which was being considered in the Diet at the time.

In America, beginning in 1850 suffragists like Elizabeth Cady Stanton, Lucy Stone, Julia Ward Howe, and

Susan B. Anthony struggled to get the vote for women. The movement lost steam when women turned their energies toward war efforts in the 1860s. At the war's end the American Equal Rights Association worked for votes for women, as well as for black men. Suffragists were infuriated when black men got the vote, but women of all races remained disenfranchised.

They were encouraged as Wyoming granted women the vote in 1869, followed eventually by other Western states. By the time of World War I, women working for the vote had learned their lesson; their attention was not diverted by the war. But it was an ongoing struggle until women finally got the vote throughout America in 1920.

In Japan the Taishō years (1912–26) saw the emergence of the "New Woman." By the twenties, a new word had entered the lexicon: *moga*, a term adopted from the English "modern girl." This Japanese equivalent of the flapper no longer stayed home, but joined the men at work and play.

Economics played a part in events. The boom period during World War I was followed by a downturn, and many women were driven by financial need to join the work force, working as servants and doing piecework at home, as well as working in light industry.

There were some proposed changes in government policy in the 1920s that paralleled the new freedom for women. Now parental consent would no longer be needed before marriage, women would get the right to manage their own property, and divorce would be easier to obtain.

Many militant women's groups were formed. In 1921 an organization for female socialists, the Sekirankai, or Red Wave Society, was founded by leading activists.

At first women hoped for support from male organizations, but, like female union activists in America, Japanese women radicals became disillusioned with leftist men. The Sekirankai was disbanded in 1925, the same year that "universal suffrage" for nonindigent men was finally passed.

In the Taishō era, women who became teachers, even though they were limited to the early grades, were greatly respected, and if they got married, they did not have to quit their jobs.

And how was it in America? Just ask nonagenerian Evangeline Lindsley. Recalling her years as a teacher in the 1930s, she says: "The minute you got married you couldn't teach, if you were a woman, that is. Now a man could get married, and he could teach, but a woman couldn't." She recalls other discrimination, too:

> *I found out that there was quite a difference in the pay between the men and the women. I was asked to fill in—one of the men got sick—so I was asked to fill in to take tickets at one of the football games. It was in the evening, after 6:00, and the man on the gate who worked with me got paid, and I didn't. When I complained, I was told, well, I was single and I didn't have the responsibilities that a married man had. Oh, didn't I? Well, it was in the midst of the depression and my grandmother and my [widowed] mother had lost their money in the building and loan debacle, and [my sister] was the only one who had any money that month because she was the only one who believed it when I told her that they were going to close the banks. She went down and withdrew all her money, so the $100 she had was all the money we had to go on, and at that time teachers were not being paid. . . . That was my experience of learning about the distinction between men and women, as far as pay was concerned.*

Women here were often not allowed to enter certain fields, physics or architecture, for example.

By 1931 a severe depression was affecting Japan. In response to the depression, militant leaders took power. By the time Japan invaded China, regulations were imposed to combat what ultranationalists saw as the decadence of the West. Women's magazines, like other publications, were strictly censored.

World War II, like America's Civil War a lifetime before, put feminist struggles on hold. To promote the

war effort, in 1942 the Great Japan Women's Organization was formed as a patriotic organization for all women.

Years later, when Fusae Ichikawa was honored for her long years of dedication to women's rights, she summed it up like this: "The professional soldiers, whom women hate, had their own way and the suffrage movement was forced to keep quiet."[9]

As to the birth control movement, Shizue (Ishimoto) Katō's studies at Margaret Sanger's Birth Control Research Institute and in Europe led her to open a birth control clinic in 1935, but the militaristic government, opting for a larger population, closed its doors in 1938.

World War II

Not only did Japan's military government promote large families in order to have a future fighting force, but we'll recall that it also promoted an ideology that linked family with the nation, both being associated with productivity and fertility.

While mothers were idealized, female workers were exploited. In the 1930s married women were pressured to stay home, while single women were drafted for military service or factory work.

Because of the shortage of men, for the first time women began to work in heavy industry; no longer were they limited to textile factories. Like Rosie the Riveter in America, Japan's women proved they could handle a man's job.

The Postwar Era

When the war was over, in accordance with the American-imposed Constitution, women received full voting rights for the first time.

But postwar Japan wanted women back in the home. The country seemed to suffer amnesia over what

women had previously attained. The "modern girl" of an earlier period had disappeared. In films of the time, says Gail Lee Bernstein, "It is as though the female factory workers, office workers, artists, teachers, preachers, entrepreneurs, volunteers, and political activists" had never existed, "and the *moga* was nothing but a figment of media imagination."[10]

Economics would again play a part, though, when the oil crisis of the 1970s brought changes to Japan's economy. A shift from oil-dependent heavy industry into a service-oriented economy led to a great need for specialized technicians, such as computer programmers. In 1970 there were 67,700 such workers, but by 1985 this number had quadrupled to 307,000.[11]

Women were particularly well-suited to the kind of precise work required. What is more, standardized office automation operations could be handled by "flow-type" labor. More and more women found themselves working as specialists or even as managers.

The stage was set for the booming years of the 1980s.

The Years of Opportunity: The 1980s

The electronics and information industry continued to grow rapidly in the 1980s. Service industries, finance, banking, retail businesses—all expanded, and companies were eager to hire Japan's elite of highly educated women to fill employment needs.

As young women earned more, they also spent more. Businesses hired the experts—young female consumers—to develop and market products for this large market.

A rise in the cost of living also drew, or pushed, more women to get a job. In the face of a severe labor shortage, companies welcomed them warmly.

Japan, always sensitive to what the rest of the world thinks of it, was also influenced by the West. Under

international pressure in 1986 Japan's Diet passed the country's first Equal Employment Opportunity Law (EEOL).

Although the EEOL was widely heralded as an important milestone, it offered no penalties for those employers who chose not to comply. It could only recommend, persuade, or encourage. The law did, however, do away with certain regulations designed to protect working women that had prevented them from working overtime or from performing certain tasks, but that had also prevented them from advancing in many cases.

The media, both here and abroad, were quick to latch onto hints of moves in a different direction. *Newsweek* reported that in light of the new law, companies were recruiting record numbers of women headed for management and gushed that Japanese women were on "the main track at last."[12] *Business Week* wrote that "change is afoot,"[13] and *The Wall Street Journal* said that Japanese women were no longer "just pouring tea"— they were headed up the corporate ladder.[14]

Women's expectations were raised in the 1980s. At least a few women were getting the same training as men because they planned to work longer.

When the 1980s economic bubble burst in the early 1990s, then, many were disillusioned. A government poll in 1992 showed that only 31 percent felt that conditions had improved since the passing of the Equal Employment Opportunity Law.[15]

Nevertheless, the genie had been let out of the lamp. Some say Japan may never be the same again.

Changes in the Making

Are things changing? There are indications that life in general, and women's expectations in particular, are indeed taking on a different cast, as Japanese seek a life-style that offers more freedom.

One female member of the Diet feels that change is definitely on the way, as women become aware of their "hidden power."[16] To harness this power, a group of national and local politicians have started the "Alliance of Feminist Representatives" to work for more women in legislation.

In Japan some look to the future with optimism. Kazuko Kamogawa, a housewife who helps in the family business, thinks that the power of the press will bring about greater rights for women. The media are already touting examples of feminist successes, and it was the media, after all, which brought about the downfall of Japan's most corrupt politicians. An educator claimed to know many women executives, including more than one CEO, and not just in the traditional female professions.

Work after marriage is becoming more and more popular among the younger generation. According to a survey by the Tokyo Metropolitan Government, more than half of the young women surveyed wanted to return to work even after they had children.[17]

The birth rate, which is low and becoming lower, serves as both cause and effect in changes affecting women. Due to the high cost of living and crowded housing conditions women want smaller families. Having fewer children in turn means it's easier to leave home and there are fewer years to devote to their upbringing, which translates into a longer span for work. Women are not as content with the all-consuming mother role as they were in the past, now that more options are opening up. There are a few cracks in the wall that separates the proper spheres of men and women.

Recent years have seen many "firsts" for females. In addition to Japan's first female Supreme Court justice, Kisako Takahashi; and its first woman Speaker of the House, Takako Doi; there's the first female mayor, Ashiya's Harue Kitamura; Japan Air Line's first woman pilot, Tomoko Azumo; and the country's first female astronaut, Chiaki Mukai. On the international scene,

Sadako Ogata has received accolades for her achievements as the U.N. high commissioner for refugees.

Although the student Yumi Mouri thinks there is more talk than action, most of those I met with here agreed that change is on the way, although it may come very slowly. "Japanese women are discovering that they have a voice, too," says Midori Yamamoto, and Mariko Yoshida thinks that "women are starting to think that they have rights too." All of those with daughters fully expect those daughters to have careers and hope they'll have good marriages as well.

Some women have always worked out of economic necessity. Now, however, there are those seeking outside jobs for other reasons, for their own satisfaction, for example, or to have some money to call their own.

Today, after so many years of striving relentlessly to see Japan reach the economic peak, men and women both are beginning to wonder whether such a life-style is worth it.

Women, especially, do not want to be slaves to their jobs. They want to go to work, do a good job, and go home. They're not willing to engage in "make-work" activities as so many men do for appearance's sake. They want more flexibility at work for themselves, and for their spouses. They want their husbands to be able to share more in the joys—and responsibilities—of child-rearing. All of which may affect how men feel about work as well.

Even the controversial politician Ichiro Ozawa, whom many hold responsible for the policies that are now protested, now pushes for more individual rights in his best-selling book *Blueprint for a New Japan*.

As Japanese people travel and see how the rest of the world lives, they want some of the good things in life, too. They want to share in the wealth their efforts have created for the nation.

The very fact that so many like the people I met with here have lived abroad and have been affected by the experience may be changing Japan itself.

In America in 1918, we sang, "How you gonna keep 'em down on the farm, after they've seen Paree?" Now—although the lyrics aren't catchy—the question might be: how are you going to keep them in lockstep with Japan's structured society, after they've seen America?

IV

The American Experience

Oh wad some power the giftie gie us
To see oursels as others see us!

—Robert Burns, "To a Louse"

13

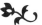

Profiles

When we travel to a different country, along with our suitcases we bring our own distinctive values and standards. After looking at the position women hold in Japan today, a position shaped by history as well as by current circumstances, we can have a better understanding of what's packed in that cultural luggage: values that include a strong sense of duty toward the group, patience, pragmatism, and a sense of the overriding importance of home and family.

To keep Japan alive in their families, a more concrete touch of home is always brought along, too. Equipment for the tea ceremony, for example, or the set of dolls depicting a miniature emperor and empress and their court for the *hinamatsuri* festival in March, or the carp streamers displayed for children's day in May. Japanese holidays are celebrated with the serving of traditional dishes. American special days are celebrated, too, but, says Yukiko Matsumoto, "We eat rice even on the Fourth of July—with steaks and all!"

Many welcome the opportunity to share their traditions with American neighbors. Haruko Ohara volunteered to demonstrate origami to her daughter's class. "I don't like folding paper so much," she says, "but I thought origami was one way to communicate."

The women I interviewed were typical for their middle-class socioeconomic level. Almost all if they had attended college had studied "feminine" pursuits: home economics, music, elementary education, fashion, languages. Almost all, even those who were graduates of four-year universities, had held traditional jobs—"office ladies," teachers, translators—and had left those jobs when the first child was born. They ranged in age from 21 to 55, with an average age of 37. Most were in their late 30s or early 40s.

"Typical" in no way means "identical," however. Let me introduce a few of those very different individuals. Let's start with two students.

Tiny twenty-one-year-old Kumiko Kinoshita's lowered head and hunched shoulders hinted at how discouraging college life was becoming. It had not gotten off to a good start, to be sure. Her roommate stole the two hundred dollars Kumiko's parents had given her for books and used it to leave school.

Kumiko missed her friends back home. It wasn't that the other students weren't friendly, but she was relieved to find out that she didn't have to join them for meals. Her studies were a problem, too. She was bogged down in a course on Christian theology without the slightest grounding in Western concepts of religion.

Yumi Mouri is about the same age. Like Kumiko she is the daughter of a transferred executive. She has been in the United States for four years to Kumiko's three. Short and stocky, she was dressed for our July meeting in a rust-colored tank top and black shorts. She'd started the day with her hair pulled back in a bun, but loose strands had escaped in the heat and humidity, rare here in upstate New York. Lounging back on the sofa, Yumi seemed as relaxed as her appearance. She says she's been able to fit right in, with both Japanese and American friends, including one very special American boyfriend. She has mixed feelings about returning. "Part of me wants to stay

here," she says, "and another part of me wants to go back." She thinks the fact that she's a music student has given her an entrée into the college social scene. She's found others with similar interests.

Yumi also seemed a little puzzled by American religion. "I never thought about religion before I came here," she says, and at school they "talk about religion a lot. I found out that my friend is Catholic and she's dating a Jewish man, and I didn't know that was difficult, and I've heard some other people talking about them, like 'what are they going to do?' In Japan we don't even think about religion."

Pretty, dimpled Keiko Koga studied music in school, too, but now, at thirty-nine, she's found other interests. She plays golf and tennis, studies English, is taking art classes, and volunteers at her children's school. She always looks well dressed, in a coordinated wool blazer and shorts, for example. Keiko enjoys life, and people. She can't resist reaching over to give a friendly pat as she listens to the person next to her. It's no wonder that she says she has "a lot of friends, both American and Japanese."

Sweet-faced Noriko Horii enjoys life, too, but in a more contemplative way, as in the tea ceremony she practices. Noriko sometimes wonders if she isn't too old-fashioned, since she was raised by her grandmother after her mother's death from cancer in her early thirties. She's one of the most thoughtful people I know. Whether this springs from her innate kindness or from old-fashioned courtesy, I don't know.

Noriko, who gave violin lessons in Japan, gets the most pleasure from music. The closeness of nature here has also been a joy: "big trees and many birds and squirrels and many animals coming to my yard."

Then there's tomboyish Haru Endo, a true extrovert with a quick and irreverent sense of humor. A teacher in Japan, she promised her husband that she wouldn't work after they were married. She adds with a sly smile, "But I did!"

Or Yoko Saito from Okinawa, who never expected to marry, but within the space of a year and a half found herself with a husband, in America, and pregnant at the age of thirty-six.

Or Yuriko Otani, stylish, poised and unusually tall. She feels the misery of her first year in the U.S., plagued by illness and by her children's school problems, was offset by the kindness of Americans and by the fact that here she could finally find clothes to fit!

There's also Chiaki Shindo, who seems feminine and soft-spoken, but who reportedly told her husband's boss point-blank that she didn't want him transferred back to Japan. . . .

How do those here view their American experience? For the most part, their perceptions are remarkably similar.

14

Living Conditions

"Space!" "Space!" "Space!" That's the most obvious difference between living in America and in Japan. Space, green surroundings, comfortable housing, and a higher standard of living. Life here can be very pleasant indeed, compared to Japan, which has a population about half that of ours confined to an area about the size of California. What's more, Japan is a mountainous country, so mountainous that only about 15 percent of the land could ever be cultivated, or essentially inhabited.

Today Japan is more crowded than ever, for half the population lives in what's called "DIDs," "Densely Inhabited Districts," with 10,000 or more people per square mile. We may consider New York to be crowded, but Tokyo numbers 32,580 people per square mile to New York's 23,705. A third of Tokyo's apartments average about 11 by 11 feet. Commutes of one to two hours—or even longer—are common from outlying areas to city centers.

American Jill Sakai describes what her home was like in Japan:

> The apartments have very thin walls, and you hear your neighbors and they hear you coughing and sneezing, and whatever you're doing. . . . Their fridges

are smaller. They don't usually have ovens in their
homes, [which] are very small. Every room seems
small. A few places are like 3 feet by 3 feet, very small.

In contrast, Yukiko Matsumoto describes her first
impression of America: "Space and green and big sky
and nature!" and Mariko Yoshino echoes: "The broad-
ness of the land, the broadness of the sky—the big sky!"

Because in Japan "everything is incredibly expen-
sive," says Fumiko Yamaguchi, all they could afford
there would be a small apartment, but "here we can live
in a house!"

Haruko Ohara is another who "really envies" the liv-
ing standard we enjoy. Everything is cheaper here, and,
with more spacious housing, there's room for the house-
hold appliances Americans have come to take for
granted: large refrigerators so housewives don't need to
shop every day as in Japan, and large washers, dryers,
and dishwashers, which make housekeeping go faster.

In Japan "they don't always have a washer/dryer,
not automatic," says Jill Sakai. "We have to change
places from the wash area to the spin area, and dryers
aren't very common." Once the clothes have spun in the
washer, they're hung on the balcony, "and you don't put
them up with clothespins, you put them on the hangers,
and then you put them on the pole outside. You hang
your futons over on the balcony ledge, but you have to
wipe the rail everytime because it's so dirty, and you
beat them with a futon-beater."

Marilyn Inoue describes her day when she lived in
a conservative city in western Japan, laughing when
she talks about her American failings as a Japanese
housewife:

> Every morning you take all your futons and bedding
> out and put it on the railing if it's not raining, and
> then you do your laundry. You can hang your laundry
> out on your little balcony, and if you haven't done all
> that by about 8:00 in the morning, the other wives

think you're lazy or you're sick. They'll even insist on coming to check on you to make sure you're OK, because any decent person would be up and doing by that point. Of course I usually didn't have all this stuff done until more like 10:00! You will of course have made breakfast for your family, and a lunch box for you husband, and you will have bathed yourself and your children, and then you'll sweep and dust, and then you will walk to the corner store. Everything is very close, every neighborhood has a beauty shop, a dry cleaner, a grocery store, a barbershop, a dentist, every amenity you would need, and if you want the bigger department store, you can ride the bus. It's not like here where you have to drive to the grocery store.

So then usually by around 10:00 in the morning you should be done with all your housework and you'll be walking to the store, and a lot of times people will walk to the store to buy fresh things for lunch and then they'll walk again in the afternoon for fresh things for dinner. Some lazy people like me get everything in one trip, if you can carry it. You have to carry everything to the fifth floor, along with the children, so—I never lost weight doing this, I could never figure it out! But usually you shop every day, and everything is fresh for every meal. You don't go and do a week's worth of shopping and put it in the freezer, because your refrigerator's so small. So you'll do that, and you'll make the children probably a hot lunch. You probably wouldn't make them just a sandwich; you'd make them a hot lunch. . . . Then in the afternoon when the kids come home from school you give them a snack and you change their clothes. Kids always looked immaculate because their moms always changed them three or four times a day. Again, I never did. I waited till the end of the day. By then you're making dinner and having a nice fresh dinner, and you'll feed the kids whenever they're hungry. . . .

So your day is all these things, and your husband expects when he comes at any time—it could be midnight, it could be 6:00—or anywhere in-between, there's a hot meal and a hot bath waiting, so you never

sit down and eat with your husband. You eat with the kids and you bathe the kids, read stories and play games and sing songs and help with homework if they have any, which they do even in nursery school. They're supposed to learn the next day's lesson. Then whenever your husband comes home, he has his bath and then eats his dinner, or vice versa. . . . Then he will have a few drinks, probably, a glass of cold beer or some hot sake, depending on the season, and you're expected to be up and fully dressed until whenever your husband comes home and has had his dinner. Well, I became bad at a certain point and I would just go to bed at 9:00, but I would get back up, but most of the women I knew would wait up, you know. . . .

Marilyn explains how you go about preparing a Japanese bath:

Now you fill the tub with water and then you turn on the gas and it takes about an hour to heat, so you have to be really on the ball. It's got to be hot when your husband comes home. Usually I would turn it on—oh, well, you never know when they're going to come. Usually they won't come before 8:00, so I used to turn it on around 6:00 or 7:00, and you put a lid thing over it, and then you make it really, really hot, almost boiling, and then it stays hot, till midnight, even, when the guy comes home.

And hot water doesn't automatically come out of the kitchen faucet, either, says Jill Sakai: "You have these buttons that you push for hot water, and you're conserving energy."

Marilyn had a similar gas heater to light. "I was always afraid of those," she says.

What's more, "very few people have central heating," even though winters can get very cold. Instead they rely on space heaters, usually fueled by kerosene.

Yoko Saito, as the mother of a young baby, especially appreciates the easier living here:

I have a daughter, and baby food and diapers are very different. It is easy to take care of a baby here. In Japan we use many cloth diapers and we have to wash them, and even baby food—we usually make, by ourselves. It takes lots of time.

Chiaki Shindo is one of many who say they can enjoy life more here because they're liberated from the time-consuming chores they had to do before. Even though Japanese houses are small, they need "a lot of time to keep up with the housekeeping" there. Now there's more time for things like golf, a special treat because it's prohibitively expensive in Japan.

There's more time for family activities, too, when husbands adhere more to American than Japanese schedules. Now it's possible to take vacations, which in Japan are limited to one or two weeks a year at most, at the same time that everyone else is traveling. "Just two or three days" was all Chiaki Shindo and her family were able to enjoy there.

For couples who live in America there's more opportunity to communicate. Here, says Chiaki, "we can talk more. In Japan we just say 'hello' and 'goodbye,'" which, as the psychologist Kumiko Muramoto has explained, can lead to marriage problems.

Japanese people living here are not unaware of society's problems, though: drugs and crime, the gap between rich and poor, and the lack of freedom to go where you want, when you want. Even though the general impression is that life is "freer" in America than in Japan, this is one freedom we might envy.

Mariko Yoshino finds that, contrary to the general impression, children can be more independent in Japan than in America, because there they can go everywhere by themselves by way of public transportation, thanks to the safety of Japanese society.

Yukiko Matsumoto is a tiny, intense woman with strong opinions on the subject. She looks frail, perhaps because she's wearing no makeup, and bookish in her

white turtleneck, rose-colored jumper and knee socks, wearing wire-rimmed glasses. She won't say her age, but her short black hair is showing a few strands of gray. She sits demurely, hands folded, in a chair that seems almost too big for her, as she speaks of living in a large U.S. city before her move to small-town America:

> We lived near areas where people would tell me not to go. I walked through those areas, and I couldn't stand to see those poor people, those poor white people and the black people who don't have much opportunity. It's so sad . . . I ask myself, "What would you wish for America if somebody could promise it?" I would ban guns, drugs. I just don't want to see drugs in this country, especially for young people. There are drugs in Japan, of course, but here it is much, much worse. Why the American government allows this, I don't know. Then America would be a very, very fine country again. They call it freedom, but *I* call it irresponsibility!

15

Choices, Restrictions

The same system that fosters law and order in Japan, however, fosters conformity, and conformity can be hard on those like Yukiko Matsumoto, who "always wanted to be special." The freedom of America which, as Yukiko claims, veers toward irresponsibility, makes possible choices that are unavailable in Japan.

"You Americans have choice," I heard again and again. "We Japanese have no choice." No choice for a guest on what she will be served, no choice over lifestyle, no choice, even, over what to wear.

To Masako Miyagi "making a choice is a very big difference between the two cultures." A Christian, she was impressed by what she had heard in a Bible study class here: "God gives us choice. That was very, very interesting," she says. "In Japanese Christianity it is not stressed, it is not emphasized, but here to choose, to make a choice, is very, very important for us, and even when we go to McDonald's I have to make a choice."

"Unspoken restrictions" rule Japanese society, according to Midori Yamamoto. "If you do things that you are not expected to do, then you are labeled kind of like an outcast."

Marilyn Inoue puts it this way:

It's not like somebody comes to your door and beats you up or anything, it's just if you do [act differently] it's going to be taken out on your children in school, it's going to be taken out on your husband in his workplace, it's going to be taken out on your husband's brothers and sisters, or your brothers and sisters. . . . Everything you do isn't just for you—for men and women, too—but reflects back on other people.

Marilyn feels sorry for the young girls who are aware that there might be other choices, but that "they aren't going to get them." She speaks of a friend

who lived abroad, had all those adventures, handled her own life, could go where she wanted, do what she wanted, say what she wanted, dress how she wanted, and then came back and had to make a living and *had* to conform because she had to have a job, because she didn't have any other backup. She didn't have any choice, and—what was that movie, *Awakenings*, with Robin Williams, where the people were in a coma years and years and then they woke up?

Even freedom of choice on what to wear is not exercised. Yoshiko Hanai, age 46, dressed in a cotton blue and white striped dress with a large bow in front, says that when she returns to Japan, it will be hard

to always consider society's views. For example, when I wear clothes like this, is this suitable for my age? Is this hairstyle good for my age? I always consider. . . . Here it is individual. If you like these clothes, that's OK and other people don't care about that.

We may not be as nonjudgmental as Japanese visitors think—they should see me agonizing in my closet over what to wear sometimes—but it's true that we're not as rule-minded as the Japanese. As Midori Yamamoto says, in the U.S.:

People say you can wear whatever you want, comfortable clothes. If you live in Japan there are certain set colors that you will wear as you grow older, and you will not wear bright colors when you grow older, but here people don't mind if you would like to wear red, yellow, or whatever when you're fifty, sixty—that's fine. That's your choice.

The choice of children's clothes also takes on more importance in Japan, says Haruko Ohara:

Before coming here [nine-year-old] Reiko didn't like to dress up to go to school, she preferred her old clothes, because if she wore cute clothes, many of her classmates would make fun of her: "Do you have a date today? Do you have a wedding today?" So she didn't like it. Actually, she would wear neat clothes, but not fancy ones, frills or colorful ones, maybe dark blue or just light blue. But since she came here, she can enjoy wearing whatever she wants to wear, and nobody makes fun of her.

Yumi Mouri, the music student, talks about the question of choice in her field. She finds it difficult to make a decision on how to perform here, since in Japan a student merely mimics the teacher's style. Technical perfection outweighs individual creativity. Now she must develop her own style.

When there is the rare opportunity to make a choice in Japan, for instance when it comes to choosing a company to work for, you have to be very, very careful, says Marilyn Inoue, for there are no second chances. "Once you blow it, you blow it," she says. She gives the example of an acquaintance who went to work for a large company, but who regretted it later:

He worked for a huge corporation, and it was like you see on T.V., where your whole life is the company. He was forced on the rugby team because he was big, and they said, "You will play on the rugby team. Be here

Saturday morning at 8:00 for practice." No choice. You must live in the company housing; your boss will probably be involved with your choice of your marriage partner; you will go to the company resorts; you will borrow your money from the company to buy your house, everything that you see. You will be buried in the company cemetery, probably. That really happens in that kind of . . . big company.

In America, however, as Yumi Mouri says, you can always change your mind. Here you can switch careers in midlife; you can pursue anything you want. There's the choice to continue with education, to continue serious learning throughout a lifetime, an option not possible for Japanese past a certain age, given the crowded status of educational institutions.

American women have "chances," says Yuriko Otani, which are denied to Japanese women, in particular being able to take classes, or even to return to college. In Japan there are classes at "culture centers," but they are very expensive, far away, and one has to dress well. There's not the relaxed atmosphere that American students enjoy.

Yoshiko Hanai thinks this "opportunity to learn" is one great advantage of living in America. When she was young her family could not afford to send her to college, so now she is overjoyed to be able to study English and music at the community college. "In Japan," she says, "it's very difficult to enter the university again after you have graduated from high school, but here even if you are working in society you can learn in school, too." She notes that even "grandmothers and grandfathers are in our class!"

You can learn, too, from the diversity in America. Mariko Yoshino thinks:

Here people tend to express their feelings, whether or not they are opinions against your own opinions, but by listening to what they have to say, if I keep my mind

open, I learn a lot. In this country I can choose what I want to adopt and what I want to reject, and you don't have to agree with others, you know, but you take your opinions and you take their opinions. . . . Maybe society in Japan limits the individual rights of choice, although the law does not forbid any choice, but the society—especially if you have to associate with older people, you have to adjust yourself to older people, that kind of thing, that kind of society.

Living in Japan means living with constant people pressure, physical, mental, and emotional. Having to always be aware of others' opinions can be stifling. There, says Chiaki Shindo, "it is very hard to enjoy golf or tennis because other people would be jealous, and if I want to play tennis, people would say, 'Where are you going? What is that you are carrying?' Here nobody wants to be nosy. They enjoy their own life."

In America, says Midori Yamamoto, "I can be more what *I* want to be, rather than what society wants me to be."

Here "I feel free!" exclaims a college student, Kumiko Kinoshita. In spite of her problems at school she enjoys being able to drive her own car and having her own apartment.

Masako Takita describes the social pressures on Japanese to conform. For example:

It takes a lot of energy to get a divorce, because the entire society, the entire family, will be against it, you know. For the same reason, the crime rate is so low. Safest country in the world, right? Because once somebody commits a crime, that's a break in the entire family. In the United States, only each individual has a birth certificate. It says only your mother's name and your father's name, that's it. In Japan, the family registration—that says the father, mother, brother, sister, the entire family's name, so if one person from this family commits a crime, the father has to resign his job, sometimes there is a suicide, the

mother has to quit her job, the sister never marries, the brother never marries. It affects the entire family. It takes a lot of guts to commit a crime, because it destroys everybody's life.

Marilyn Inoue had a Japanese friend who had married a divorcée with two children and who was being harassed by her ex-husband. "'Why don't you have the guy arrested?' we asked," Marilyn says, to which her friend replied that, even though he had adopted his wife's children, their names were still on the ex-husband's family register, and if the man were arrested and convicted, it would reflect on the children and affect their future, and "so he paid this man an outrageous sum of money."

She explains that living in such a controlled society means that

> people are taught not to incite other people's envy, so if you have something good or something nice, you don't flash it, and you don't have more or better than other people. You have the same, not more or not less. If you have less, you're going to feel dissatisfied. If you have more, other people are going to feel dissatisfied. Everybody has to have the same. So everybody has the same clothes, the same cars, the same appliances.

She describes an incident she experienced before she was well-versed in Japanese ways:

> I goofed one time because my husband bought a video camera to take pictures of my son when he was a baby, and my Japanese was fairly limited at the time, so there were a limited number of comments I could pass with the neighbor ladies when we were outside when the kids were playing, and—it would be very typical of an American—I said, "Oh, yeah, my husband bought a video camera. He doesn't really know how to use it." Because it was an easy, simple sentence I knew how to say in Japanese, basically.

My husband came home the next day, and he was furious, absolutely furious! "What are you doing telling everybody we have a video camera?" "Well, lots of folks have video cameras. What's the big deal?" "Well, now Mrs. Blah-blah-blah wants her husband to buy a video camera because Inoue-san has one, and Mr. Blah-blah-blah's mad at me because he doesn't want to buy it, and blah-blah-blah." I guess everybody else in our block didn't have one, and they thought I was bragging, and they all thought that that meant that they all had to go out and get one. "Inoue-san's wife has a video camera. Why don't we have one?"

You know, the most innocent remark! So you don't incite other people's envy. If you have something, you just don't mention it, and you don't take it outside, and. . . .

He would never let me do barbecues on the veranda, because then everybody would know what we were eating for dinner, and "so what?" And he'd go, "But we'd be having a good time in front of other people."

Marilyn laughs as she continues:

Now, it's OK to have a good time, like to be drunk under the cherry blossom trees in Tokyo, because everybody else is, or you're in your group, and you don't care about people outside your group, but when you're living in company housing, everybody in that company housing is your group, and so you can't have fun in front of the other people unless everyone is included, and that's one of the ones that used to kind of irk me. Americans, we say, "Oh, how immature! They're grown-up; they don't need to feel envy. They can buy a video camera if they want one. If they choose to spend their money on something else, what's the big deal?" That was my take on it, but his take was, "You're flaunting something that we have in front of other people." He was quite upset over that.

Have those who have lived here been changed by their American experience? Some state specifically that they have indeed been altered by the stay.

Away from the confines of a crowded country and its restrictions, many find that their very personalities seem to expand in America's open spaces. No longer do they limit social interaction to their own small group.

Keiko Watanabe says that being in America has "broadened my sense of how to see people, how to relate to people," as she has become "more open, informal."

Those in Japan are often considered xenophobic, but "from now on," says Yuriko Otani, "my views of foreign people will be different," thanks to the warm welcome she and her family received here. Haruko Ohara admits that "before coming to America, I thought, 'I don't like America,' but I like it now, and I like Japan, too, and I can see both sides, good points and bad points."

If Masako Miyagi had stayed in Japan, she believes, she never would have been so interested in learning new things, in facing new challenges.

Yoko Saito's husband tells her that at home her ideas were very conservative, "narrow-minded, closed," but now she, too, has become more open to people.

Chiaki Shindo, who so much appreciates the opportunity to communicate that she and her husband now have, adds that "I have changed so much because we learned how we need to enjoy our lives and not just raise children, not just live together. We found more purpose in living together."

Being in America is a time of freedom and a temporary escape from burdens at home. Some women are going back to shoulder family responsibilities, to live with in-laws, perhaps, an obligation they're not looking forward to.

As Masako Takita explains, such responsibilities are still a big part of life in Japan, even as the country has become more urbanized:

There are 30 million living in the Tokyo area, right? Those people came from the countryside, so the Japanese system still is that the first son carries on the house, because the parents are living in the countryside. . . . but when the parents are getting old, they [the first sons] go back to the hometown and they live in that house with the parents, so those living in the tiny apartment in Tokyo, they're the second or third son, or someone who doesn't have any duty to live with the parents.

One of Fumiko Yamaguchi's concerns about returning is just such a responsibility, because she fears she'll have to take care of her husband's parents.

Fumiko's life up to now has been pretty glamorous. After graduating from college she worked first in the foreign exchange department of a bank, then as a "kind of fashion advisor," selling designer clothes to wealthy clients.

When I met her, she had just come in from playing golf. With no children yet, she's free to take a ceramic class, pursue her calligraphy hobby, go shopping when she feels like it, have lunch with friends.

Her advice to others coming here is to "try to go out—go to school or play tennis or play golf, but go out of the home; have a party!"

For all too soon it will be time to go back to Japan and face the real world again.

16

Education

"The Japanese education system is not good, and that's a problem," Shizuko Kojima says bluntly.

The children's time is so taken up with study that they have no time for outside activities, like camping, skiing, or the many other things American children enjoy. Japanese children have much more pressure than American children: "They are pushing, pushing, pushing their studies," says Keiko Watanabe, who prefers American schools.

"Japanese children end up with a narrow mind, very narrow views," notes Yoshiko Hanai, "but American children have varied views because of their education." Indicting the Japanese government, she states that she's read that its aim is "to educate children as the army of business. They want to systemize everything in society—organize the system of the society—but the American education is individual; freedom of the individual is important."

Anne Allison, whose child attended a Japanese nursery school, remarks that indoctrination begins early: "Children are being programmed at ever earlier ages to assume a posture of productivity that will continue into later life."[1]

In a letter to the *Japan Times*, a teacher named Matthew Lowe also blames the "system" and "the bitter

middle-aged men at the Education Ministry" for the "problems and strange ways of acting" that he sees among his students, who seem to be preoccupied with death and who list their favorite hobby as "sleeping." He writes:

> I often see groups of children together—no one speaks or laughs, they all have a [comic book] pressed to their faces, which they read even when walking. . . .
>
> Students are absolutely amazed that I, as a teacher, have hobbies and interests, that I work and go out and enjoy myself, too. I'm 12 years older but have far more energy and lust for life. I'm also busy at home but they tell me their mothers do everything for them.
>
> How do parents feel about these things? Aren't they shocked or worried? Do they notice? How do teachers feel? What are they going to do?[2]

Parents *are* worried about their children's education in Japan, especially those who have had a chance to compare their children's schools in Japan with those in America.

Yukiko Matsumoto recalls that all they did when she was in school was "memorize, memorize, memorize!" Yukiko's dangling earrings vibrate as she shakes her head indignantly. Each time she nods forcefully, her glasses slip down her nose. She pushes them back impatiently. "In Japan they indoctrinate children," she continues:

> I survived, and my husband survived, too, but I can't say I am a winner in that system. I wish I had had a much freer education. I wish I could find my own way, not the way that I did. I did my best to be Number One at the time. I was encouraged to be Number One all the time, and I survived. . . . I survived, but so what? What am I? . . . It is not enough to make me happy, and that part, American education gives to my daughter.

I went to my daughter's school, and a wonderful, wonderful teacher taught me a lot about what an education should be. My daughter, with Asian features, was taught that she was very special. She has to be happy. She has to feel very confident with herself, and that is the way of American education. My daughter will find her own life. That teacher had to encourage me, and teach me, and enlighten me. That was wonderful.

In Japan you are discouraged from being a special person. There isn't that American attitude of special kids at school. Japanese education is to make "ordinary Japanese people. . . ."

American schools could be improved, though, she thinks. They could teach the children how to work. What is more,

I don't think it is important to have lots of knowledge, but still with math education, training your brain, American education could do much, much more. In Japan there is so much training in math and science, and that is something Americans can learn from them.

Haruko Ohara agrees that the educational level, "or maybe just math," is low in the United States. "The difference is that Japanese children bring a textbook home with them, and they are able to study tomorrow's textbook at home, but in the U.S. the children need not study at home."

On the other hand, Haruko credits American education with making nine-year-old Reiko more able to express herself. Since being here, she often says, "That's not fair! That's not fair!"

Isn't this a bad thing, I asked, like talking back? Haruko replied:

I don't think so. I think she knows that she has some rights to claim, but not in Japan. "That's not fair!"— that's a really unusual saying in Japan. When she was in Japan she didn't say that. That's interesting.

Haruko thinks it's good that she expresses herself more, and that "she need not worry about her friends' opinion. She can be herself."

Keiko Koga points out that her daughter's math class at the Japanese school was a full year ahead of that in the American school. In science and music, too, Japanese students excel. Education in Japan, however, focuses too much on tests:

> Scores are very important for Japanese children, so they have some techniques for getting good scores, but that's not real education, I think.

American "experiential education" is better, is the opinion of Chiaki Shindo, too, even though our system could be improved. Our school year is too short, for one thing. In contrast to Japan, she says:

> Here if a student has ability, the teacher will want to develop it, but in Japan they require everyone to be the same because they need to pass the entrance exam for the university. In Japan the system is geared toward passing the exam. They also teach the students to just remember things, but here [it] is based more on experience—how to feel or how to think.

Shizuko Kojima describes the difference between Japanese and American education as she sees it:

> Most Japanese mothers think their own child has to go to a very nice school and graduate from a very nice university, and then get a very nice job. It's the best life for the child. So every child has to study very hard every day and even six- or seven-year-old children after school—they have to go to the *juku* and back home at a very late hour, 10:00 or 11:00 in the evening. That's not unusual.
>
> I'm very worried that the [power of the] education system . . . is getting to a very high level. . . . but mind or independence is getting very low, because the mother

always takes care of the child and the mother always goes with the child everywhere and every time the mother [has to tell the child what to do, because] the Japanese children cannot think for themselves. That's very important and so Japanese adults have to think about what's very important for life, education or mind or. . . . Now most 20-year-old, young Japanese men and women have already graduated from a very nice high school and they have a very good mother for education, but their mind is changing very little.

"I'm glad my kids are getting an education in the United States," says Masako Takita, because

they know how to speak, how to express their feelings. . . . An American education brings out the children's ability. [My son] is good at artwork and also mathematics, you know, so even if he has weak points, the teacher can bring out his abilities, so he never loses confidence. But in Japan, in the Japanese educational system, only one curriculum is provided by the minister of education for all of Japan, so there's English, math, sociology, everything—you have to be good in everything, and whoever flunks, even one subject, he is a failure—that's a failure!

In American schools children, like their mothers, become more open and self-reliant. Just as young Reiko Ohara can now "be herself," the Shindo children and others have become more independent.

It may be a case of thinking the grass is greener on the other side of the fence, but most Americans think that children get a better education in Japan than in the United States. Ironically, the Japanese take a different view. Most are not pleased with what their schools have to offer there.

17

American Women

What do the Japanese women living here think about American women? We are very nice, very friendly—"I was surprised at the smiles," says Chiaki Shindo—but we know little of the outside world, Haruko Ohara thinks, a notion repeated by Americans who have lived in Japan for considerable periods.

Dottie Duff was dismayed by the lack of international news in the local newspaper. Debbie Peterson found that the hardest part about coming back to America was the culture shock of learning that

> everybody in middle America gets caught up with what's going on immediately around them, and they have some pretty grand stereotypes of foreign countries. They're very confused about Asia. "Oh, you were in Japan? Well, those Chinese are really, . . ." you know. They get really confused, and you try to say, "Japan and China are nothing alike."

Some here envy the support that American husbands seem more apt to extend to their wives, but Japanese women do not have a very good opinion of what American women may call their search for "self-fulfillment." To Japanese eyes it seems more like selfishness.

"Here I'm not sure the American ladies' goal is to have a happy family or not," says Midori Yamamoto. American women do not find the life of a housewife and mother fulfilling, she thinks, "so they feel 'I have to get out in the society and show what I can do, so I feel that I'm living.'"

Most Japanese women, on the other hand, "feel that their life is within the family. They take care of the children, take care of the husband. After the children grow up, yeah, they can have their life again, but before the children grow up and get out of the house, their place is in the family."

Fumiko Yamaguchi notes that "an American woman, after she has a little baby, she goes to work, and I don't like it. It is not best for the baby, a very little baby."

American mothers neglect their families, Yoshiko Hanai agrees. Here "women only consider themselves! If she wants to work, who will take care of the children? But they always think '*my* life is more important than the children.' The children are also their life."

In some ways, though, she envies the life-style of American women. They "can do everything without considering society," but she also pities them because they are "too selfish, so they corrupt their life-style by themselves."

She thinks, as do others, that American mothers neglect their children's nutrition, and she blames the obesity of so many American children she has seen here on this neglect. (Others think the fact that we drive everywhere is a factor.)

Haruko Ohara also commented on the number of overweight youngsters she'd seen, which she thinks may be due to the extraordinary amount of sweet snacks they consume.

I wonder if it's because good food was not always available—Kazuko Kamogawa remembers after the war foraging for food she normally wouldn't eat—that Japanese women take nutrition very seriously.

Noriko Horii commented that Japanese housewives cook fresh vegetables every day, but "when I ask how to cook a strange vegetable, American women say, 'Oh, we don't use the fresh vegetables. We use canned!'" she recalls with a laugh. The school lunch that a Japanese mother packs "is extremely important in the lives of most Japanese women," writes Deborah Fallows, whose friends in Japan were eager to instruct her on proper preparation.[1]

In a way, what Japanese women here consider an absorption with self can have a positive side: American women are more in control of their lives, more independent than Japanese women, Shizuko Kojima thinks. She and Mariko Yoshino agree that women here are more serious, more focused about their lives than Japanese women: "They have more deep thoughts about themselves; they're more concerned about their careers, their life itself, and their children, too."

After all, Mariko adds, we must remember that women are human beings, too, with certain rights. But she, like so many others I met with, think the high American divorce rate can be blamed on the self-centeredness of American women:

> I think they seek their happiness or their well-being before they think about their children, and I think they have a philosophy that unless they're happy, the children cannot be happy, but they are neglecting the fact that divorce may affect their children.

Haruko Ohara sees it as a generational thing. Most of her American friends are older than she, not among the younger generation, because, she says, "honestly speaking, I don't like them. They're very self-centered, very selfish, I feel," and less patient than their Japanese counterparts.

Although American and Japanese women share a "belief in the family life and children's education," the big difference, outspoken Masako Takita thinks, is that

"the American woman's center is herself. 'What about *my* life?' In *Kramer vs. Kramer* she says, 'What about *my* life?' to her husband and child, you know? Japanese mothers, they never say that. They don't have a life until children go to college. . . ."

American women "insist too much on women's rights," says 40-year-old Mariko Yoshino. "Capable" would describe Mariko. Her round face dimples when she laughs, which she does frequently, but a word from her can make her sons snap to attention. She seems to be very much in control, of her family and of herself. A compact figure, she always looks well put together, whether she's dressed in jeans and sweatshirt or in a color-coordinated skirt and sweater. Her hair is neatly trimmed, her gold earrings tasteful. She's the only person I know who can tie a scarf artfully across her shoulders and have it stay right where it belongs.

American impatience comes across to her as just so much whining:

> Americans, not only women, complain about too many things. To me there are many things that *they* can do to correct the situation. They voice out too many things that are not necessary. Sometimes they make themselves look like . . . complainers, crybabies. [Mothers] complain about the school system; they complain about the teachers; they complain how the classes are, the materials that they use. But the important thing is the child, how the child behaves, how the child does the work, takes responsibility, that sort of thing. So I would go to my child first, as a mother, instead of voicing out or pointing out what the problems of the school are.

It's important to teach the child responsibility, she thinks, because "people have to be responsible for the world they live in." In American schools,

> the cleaning job is done by the janitors or the custodians of the school, but in Japan children pay respect to

what they use, and they clean up their own rooms, they pick up their own trash, and. . . . Well, I guess kids need to be taught what they have to do in order to be a part of the society they live in.

She thinks it's a good thing that, in addition to learning responsibility, from early childhood on, Japanese learn how important teamwork is. "I feel the individual is very important," she says, but on the other hand, as she reminds me, even we Americans say that two heads are better than one. "Of course each person has to be educated, has to learn, has to be polished so that the group can perform much better, but there are many things that you cannot do alone, you have to be working as a team. . . ."

Patience, too, is acquired at an early age, and is a virtue in which Japanese women take pride. Mariko admires the example of an acquaintaince who was in an unhappy marriage for years, but who finally worked it out. The American divorce rate might be lowered if Americans would just show more patience, she says:

> Just a little tolerance, you know, to tolerate the situation may improve the relationship, rather than rushing in and trying to find a different person. So maybe that's what, in general, American people may want to try.

Yumi Mouri, the music student, also thinks the low divorce rate in Japan is because

> most people, they are just patient. I have this attitude about everything: I'll just deal with it. But it's not very good for yourself. I don't think Japanese women think about their happiness that much; they think about others' happiness more than their happiness.

Keiko Koga is another who thinks the low divorce rate in Japan is due to female "patience—*gaman*. Patience for their children," as does Akiko Nakayama. "Japanese people think of the children more than them-

selves, but American people think of themselves," she says.

Masako Takita doesn't mince words. "Americans have no patience," she thinks. "That's why the divorces. No patience. And they change jobs. No patience." And women want their own lives while their children are still young. No patience.

"I think Japanese women are more patient," Yoshiko Hanai agrees. "Sometimes patience helps to make everything happy. We believe that. Most women believe that. While women are bringing up the children, at that time we think, 'I want to go out, but I can't, because of the children,' so, have patience." And this patience will lead to happiness.

Patience is part of the greater concept of time, a concept that differs in Japan from that in America, explains Marilyn Inoue. There is a more extended view of time that is part of the spirituality she senses in Japan:

> Americans tend to think in words, in actions, and right now, in real, concrete, in the here and now all the time, [whereas Japanese] always have an awareness of what season it is, what flowers, insects—they always have an awareness of the people that are dead and gone; they always have awareness of future generations.

> It's an awareness that you're not an individual in charge of the world. You're just part of the web. . . . And there's a sense of time. We're not just here and now; there's all the past that came before, and there is the future that goes beyond and the future generations in the children. I think that's why people are so wrapped up in the children.

The sociologist Sumiko Iwao speaks of how the Japanese take a long view of life, with a

> long-term perspective . . . to gain and loss, happiness and unhappiness, satisfaction and dissatisfaction, which is constrained by a consideration of others and

the surrounding situation. Happiness may not be possible now or even five years from now, but if one perseveres and endures, it will eventually be possible. The time frame in which Japanese women seek their goals appears to be much longer than that of American women, who seem to be intent on satisfying their current desires and goals as soon as they possibly can.[2]

Patience, and endurance, are considered strength, says Marilyn Inoue, who explains this Japanese concept of strength:

> Japanese people have a real thing about the strong person [who] gives in because the weak person needs [it]. . . . Americans think being strong is always winning, and Japanese people think being strong is not needing to win, especially for women. . . . You give in and go with the flow, and then you're the strong person, because you are able to handle it.

So there are different definitions of strength. In Japan someone who can endure adversity with patience is thought to become a stronger, better person for the experience.

There's another difference. We Americans think we are strong if we have individual control over a situation, what psychologists call "primary control." In Japan, "secondary control" is preferred. Feeling in charge may mean aligning ourselves with a group and enjoying control vicariously, or even accepting things the way they are.[3]

By the Japanese definition of strength, American women, impatient and assertive, must seem to fall far short of being strong, but Japanese women are indeed "steel butterflies."

18

Connections

In spite of the differences between Japanese and American women, there are those who think there are more similarities than differences, many "connections."

Both face similar problems in pursuing career goals, for example. And of course the same basic moral standards apply for both cultures. As Mariko Yoshida says, "good is good, and bad is bad," whether codified in the Ten Commandments or in Buddha's Eight-Fold Path.

Bonds of affection exist in families of both cultures. As Tolstoy said, "All happy families resemble one another; every unhappy family is unhappy in its own fashion."

Masako Takita thinks women of both countries have "a belief in family life and in the children's education." Mothers in both Japan and the United States are the ones who are primarily responsible for bringing up the children.

Chiaki Shindo has found among Americans the same feelings of obligation—*giri*—as in Japan:

> Whenever I take care of somebody's child, they feel they have to take care of my child or do something in return. As human beings, I think Americans and Japanese are similar. I think the American people think *giri* more than Japanese people—some people do.

Although she senses differences between older Japanese and Americans, Yoshiko Hanai thinks that among the younger generation, "those in their 20s and 30s—there are similarities. . . . My children's generation has completely American ideas."

Yumi Mouri claims that American women her age are "not really" different from her friends in Japan. "When we talk about our life," she says, "everyone has the same problems," especially when it comes to "social life, and how to deal with social life while you're in school. It's very difficult. You can't really socialize that much," when studying must come first.

Jonathan Rauch was relieved when he traveled to Japan to find that although it was different, it was "not *especially* different." He kept running into "all the familiar types" of people he met at home, and thinking he recognized familiar faces.[1]

I had the same experience. The gracious wife of the Buddhist priest who served us tea and cookies seemed, and even looked, a lot like Ann, my next door neighbor. What was it about Shizuko Nakajima that reminded me of my aunt Ethel? Was it her small chin, her fidgety ways, or her coal-black hair in a page boy? And I felt a closeness to her jovial husband because he was so much like one of my brothers-in-law.

There was a sense of homecoming, too, when I read some of the works of Sōseki Natsume, Japan's best loved novelist, who lived in the early twentieth century. His books are thoroughly Japanese, and yet his characters have a universality that transcend time and place. There's the bustling older sister who talks too much, the black sheep uncle with his get-rich-quick schemes, the money-grabbing foster father, and schoolboys "who believe they have the right to annoy teachers as part of their education."[2]

"Yes, yes!" Yoshiko Hanai, agrees, you *do* see the same personality types in both countries. "Some Americans are really shy," she says, the same as in Japan, while some Japanese have more outgoing personalities.

In spite of the differences Masako Takita sees between us, "each individual is different." She, too, thinks people in both countries can be friendly and outgoing or painfully shy. She mentions the case of a Japanese exchange student who was so timid she refused to leave her room, while another had such a busy social life that he hardly stayed home at all.

Keiko Watanabe says, "Somehow I feel that people are the same, no matter—there is no difference. Some Americans are nice, and some are mean. Just like in Japan!"

Yukiko Matsumoto also thinks that "there are more individual differences among American and Japanese women, more individual than cultural." She found that the American and Japanese ways of life were not so far apart as she had thought when she first came to the United States as a graduate student, when she had to take an English writing class:

> One day the teacher had a talk with me. He called me to his office and said, "What did you write here?" I explained what I had written about husband-wife relationships in Japan and in the United States. I wrote that in America "husbands and wives are always equal and husbands always help their wives with their housework, while in Japan the husband doesn't help the wife, and da da da da da." And he said, "What is this? This is not true. What America are you talking about? . . . Where are you getting that? Perhaps what you write in here is right, but most American families are not like that." I said, "Are you going to disappoint me?" He really tried to discourage me, and I found out that he was right. So this is a similarity again, at least where I live.

Couples in the rural Midwestern town in which she lives are much closer to the Japanese model.

The Hollywood image of America projected to Japan differs greatly from life as lived in the heartland, as Misako Miyagi learned:

> Japanese people in general think American culture is free—you enjoy freedom and people can do everything they want to do and there is a very easygoing way, but I found that's not true after I moved here. People in my generation are more conservative in the good sense and less easygoing. They are much more conservative than I expected.

People in Japan may all seem to be conforming, and they probably are—on the surface. Again, what's not seen is just as important as the visible.

Jonathan Rauch speaks of Japan as a nation of "closet individualists," and Marilyn Inoue describes how people maintain their individuality in spite of constant pressure to conform.

She had a Japanese friend who had been rebellious at one time and who left Japan to live in England, but who finally returned and accepted being Japanese again:

> She said, "I can't fight all my life. This is my country." And she just kind of sank back into it, but still inside their heads, these are the people who have this other life, inside their heads. It's completely different from their lives outside. And that's their real life, and this other life that's outside their head is not the real life. The real life is inside their heads. . . .
>
> A lot of people have esoteric interests like foreign films. They had secret kinds of hobbies, men and women. . . . A lot of people had secret interests or dreams.

Marilyn herself is a kind of "connection," a bridge between two cultures. Haru Endo had insisted I meet her, because "she is an American but she is just like a Japanese woman!" How so? Well, for one thing, she would wait patiently for over an hour to pick her husband up at work, she told me.

To me, though, Marilyn was as American as slam dunks, sound bites, and CNN. Now in her midforties, she was wearing shorts and a T-shirt with a vaguely

astrological pattern. She interrupted our talk to settle squabbles among the neighborhood children, get some Popsicles for all, and laugh with her little boy about a trip to the emergency room that had somehow involved clapping her hands together with superglue.

She called to mind what was best about the sixties, when young people hoped to go out and change the world. Born in a Western state, she taught the children of migrant workers and became a teacher on an Indian reservation. In the adventurous spirit of the period, she spent some time in Ecuador, taught in Australia, and eventually became an English teacher in Japan.

One of the best things about living in Japan, she says, was "feeling more complete." Some Japanese people coming to America find that there is a part of them that they could never use in Japan—an energy or an eagerness to change things—that is released here, she says. In the same way, she explains:

> There was always some part of me in America that never felt complete, and in Japan it felt complete. . . . In Japanese you can think without words, which I can't do in English. . . . You learn by observation, because people are very, very observant, and they don't always say everything that they think and observe, but it's there. And there's a whole intuition, or a whole other part of you, and I always felt that inside myself from the time I was a very young child, but it never had an outlet in America. And there it had an outlet.

Still, she realizes that basic human nature is the same in both countries. Using the example of the video camera purchase that so distressed her husband, Marilyn compares American and Japanese attitudes toward a common human failing: "Americans are taught not to envy and Japanese are taught not to incite other people's envy." But both are approaching the problem of envy. "I guess that's just one more example to me that we're not different," she says. "We just take the same

things, we approach it in a different way, or we cut the cake in a different way, but it's still the same cake. There are still the same human conditions."

She gives rice as another example. In Japan it's the main dish, but in other countries it can be a side dish, but it's still "the same rice."

> It's not that we're different, completely-different-opposite, or we have things that the other people don't have. It's just that we take the same thing and we look at it a different way. . . . We put a different emphasis, or you handle it a different way, or you think about it a different way, but the thing itself, the human relations and all that, is still pretty much the same.

Summing Up

It becomes obvious that different chords of
human potential are played fortissimo in certain
cultures and pianissimo in others.

—Alan Roland, *In Search of Self in India
and Japan: Toward a Cross-Cultural Psychology*

Gary Althen, a foreign student advisor, will often ask
his graduating students to make a list of the pros and
cons of life in America. Foreign students may admire, for
example, our "general sense of freedom" but dislike our
"excessive individualism." Our weaknesses and our
strengths are revealed to be two sides of the same coin;
"most of the items on the don't want list are related to
items on the do-want list," Althen says.[1]

The reactions of the Japanese sojourners are similar
to those of Althen's students. They appreciate the sense
of freedom, the individual attention given to their chil-
dren in school, the general openness of American society.

On the other hand, too often freedom veers toward
what Yukiko Matsumoto calls a lack of responsibility,
and independence takes a turn toward selfishness,
according to Midori Yamamoto, Fumiko Yamaguchi, and
others. Americans in general lack the security of Japan's
highly structured society.

151

Although we are alike in many ways, because of our different histories, religious traditions, and even geography, Americans and Japanese have taken different approaches to basic human problems. Japan is a homogenous society, one that relies on long-term relations and that doesn't welcome outsiders. America, on the other hand, is an immigrant society, more open to newcomers. Being outspoken in America is a virtue; understatement is the rule in Japan.

In Japan self-discipline, endurance, and harmony outweigh independence. As Marilyn Inoue noted, from birth an American child is being taught one lesson: to be an independent individual; a Japanese child learns another: the importance of mutual dependence.

If we can extend the music analogy of Alan Roland in the epigraph, the music of Japanese society might be a Mozart composition, tightknit and predictable. American culture might be more like Dixieland jazz, where each musician takes off to do his own thing, but still remains part of the band.

Too often we misunderstand each other, it seems, because both Americans and Japanese look at life through our own cultural lenses, prisms that offer a distorted view.

Because I write about Japan and teach classes on its culture, I am often asked to speak to civic organizations. "Isn't it true," someone will invariably ask, "that Japanese women are really weak and subservient?"

Especially in light of Japanese definitions of strength—not always exercised in the first-person singular and equated with endurance—Japanese women are strong indeed, and history shows us that this strength is nothing new.

What we see as a subservient manner may be mere form in Japan, one of many types of behavior fostered to smooth over dealings with the "outside" world.

Our impatience, our "here and now" thinking, may strike Japanese as weakness; patience is a "fortissimo

chord" in Japan, where a different view of time influences attitudes.

Taking a long-term view, a mother knows that even though she may be "a slave to her child," the child-raising years don't last forever. Today's low birth rate and long life span has given women many years ahead to call their own. Patience will bring its own rewards.

Japanese women and American women do have striking differences, and yet we have much in common. As Takie Sugiyama Lebra says, "A woman, Japanese or non-Japanese, is an individual person with inner feelings and thoughts, aspirations and frustrations, and an awareness of a unique self-identity."[2]

Among the things that unite us is that we share the basics when it comes to what we want out of life. We both want the satisfaction of being productive members of society and being respected for what we do.

Where we differ is in how to achieve these things. We American women are more apt to see the public world as the door to self-esteem, equality, and freedom. It is still the private sphere, however, which offers the best opportunities for Japanese women. As Kumiko Makihara puts it, "To many Japanese women, the apron strings are a symbol of power and independence."[3] The life of a "salaryman" offers little to envy, on the one hand, while on the other, there are many advantages to the housewife's life.

In Japan, where doing the expected thing is a "virtue," the expected role for a woman is still the domestic one. "Most Japanese women have been raised to consider the domestic realm their foremost responsibility, marriage and motherhood their primary goals," says Millie R. Creighton.[4]

Pragmatism is another strong theme in the Japanese symphony. Contrary to what Americans may think, it's not a lack of strength that keeps Japanese women primarily in the home, but rather a sense of practicality, as well as priorities.

Consider the public world in Japan. Ichiro Ozawa, for one, laments that "people have become mere cogs in the Japanese corporate wheel" and that "Japanese people work long hours and are almost completely subject to the will of their companies";[5] R. Taggart Murphy refers to "the masked coercion of Japanese business life."[6] Businessmen in Japan have a hard row to hoe; career women have it worse. Their chances of success are woefully slim.

Moreover, when they compare the position of their American counterparts, it appears that we've relinquished power and esteem in the private sphere for disappointing gains in the public sphere. American women may be ahead of Japanese women in this realm, but they are still well behind men.

Betty Friedan thinks "the gap between women's earnings and men's is greater than ever,"[7] while Susan Faludi notes that "majorities of women say they are still far from equality." She asks, "So how exactly have we 'won' the war for women's rights?"[8] "People are saying that all feminism ever got us is more work," according to Heidi Hartman, director of the Institute for Women's Policy Studies.[9]

"In American society," says Debbie Peterson, "we exist as if there is supposed to be a change. We talk as if there *has* been a complete change, and there really hasn't in a lot of ways, and the Japanese—I think they're much more honest about the fact."

In Japan, should a woman choose to forgo the private sphere, perhaps finding it intellectually frustrating, it is possible to succeed in the public sphere. It will, however, require greater strength than it would in America, given the greater obstacles for anyone there who marches to the beat of a different drummer.

Nevertheless, women have shown what strides they can make, especially during the 1980s, even though their way—avoiding confrontation in the Japanese manner—may not be the American way. Paying homage to harmony, they've been carrying out what's been called

"a quiet revolution." Changes are occurring, even though change comes slowly and without fanfare in Japan.

Will Japanese women use their strength to progress further in the public sphere? Every indication is that they will, but when they do, it will be at their own choosing, at their own rate, and on their own terms, in a more worker-friendly public world that allows men, as well as women, to lead more fulfilling lives.

Appendix A

The Professions

Women in Medicine

Beginning in the nineteenth century there were women doctors in Japan, as in America. By the 1970s the percentage of women doctors in Japan was greater than that in the United States, says the historian Mikiso Hane.[1] In the 1990s, however, only 5½ percent of Japan's doctors are female.[2]

The comparable figure for the United States is 19 percent,[3] but they are paid less than male doctors, presumably because few are in the high-paying specialties.

The nursing profession in Japan is said to lag behind that in the United States. Nurses are low-paid and overworked. On an average they have to work eight and a half night shifts each month. For this they are rewarded with pay that amounts to 20 percent less than that of the average office worker.

Because there is no continuing education, the quality of nursing is considered poor: "The nursing school system in Japan is about 15 years behind that of the United States, . . ." said a nurse who had had the opportunity to see our system firsthand.[4] So unsatisfactory are such working conditions that in 1991 an estimated one hundred thousand nurses all over the country went

on strike. Hospitals in Japan have about half the number of nurses that those in the U.S. can count on.[5]

Women in Engineering

Only 3 percent of Japan's engineering students are women,[6] compared to 15.7 percent in the United States,[7] and they suffer discrimination. Female engineers meeting in Tokyo verbalized some of the unfair treatment they've experienced: Companies won't send women engineers to other countries to study, as they do their male colleagues. Women who seek research positions are required to have a Ph.D., unlike men, who can get the same jobs with an undergraduate degree. Women engineers felt that they were treated no differently than were women clerks and OLs in the company.[8]

Although there are said to be 62,000 female engineers in Japan, it is difficult to estimate how many are actually employed as engineers.[9] A friend was shocked to see that in the Japanese factory he visited, women graduate engineers were working just as technicians; only males had true engineering jobs.

The Legal Profession

A law passed in 1893 allowed only men to be lawyers, but under pressure from the women's suffrage movement, the law was amended in 1933 to admit women to the bar. In 1938 the first women passed the bar exam, but before World War II women could not be "public servants," that is, judges or prosecutors.

Today government policy limits the number of lawyers, although there has been a gradual increase since 1949 in the number of students studying law. About 5.6 percent of Japan's attorneys are female.[10]

The economic boom of the 1980s led to more job opportunities for lawyers of both sexes, but women find it hard to attract profitable clients, due to prejudices about their abilities. Prosecutors are subject to transfer, always a problem for women, and as yet no woman has

become chief or deputy prosecutor of a local prosecutor's office.[11] For the first time, though, Japan's Supreme Court has a woman member: Kisako Takahashi.

In the United States, in contrast, almost half of all law students are female and women make up over one-fifth of all lawyers, but still only 11 percent of the partners in the top law firms are women.[12] Even though a record number of women have been appointed to the federal bench—almost one third of new appointees have been female—in the private sector women lag far behind. They're paid less, are promoted less often, and have fewer opportunities than their male colleagues. Sexual harassment, as well as discrimination, continues to be a problem.

Academia

Although women are said to be respected as teachers of the young, according to one woman instructor at Kyoto University, discrimination is rampant in Japanese institutions of higher education, so she hopes to continue her studies in the United States. The statistics reflect her observation: Japan has one of the lowest figures for women teaching in institutions of higher learning, 8 percent[13]—while full professorships are held by only 5½ percent.[14]

Evidence exists that there is considerable discrimination in this country, too. Women with doctorates earn about $13,000 less each year than men with similar qualifications, and male professors earn some $7,000 more annually.[15] Women, who make up 30 percent of the professoriate, are less likely to receive tenure, no matter what their field of expertise.

Appendix B

Politics

For a while it looked as though women were making permanent inroads into the political world. Following the example of Takako Doi, the former head of the Socialist party who went on to hold the highest office ever held by a woman, that of Speaker of the House, other women ventured into politics. Harue Kitamura of Ashiya City became Japan's first woman mayor. After the 1993 election, three women were named to cabinet posts, heading the Environmental Agency, the Economy Planning Agency, and the Education Ministry.

Mariko Mitsui, a member of the Tokyo Metropolitan Assembly, also made political news. She established a hot line for sexual harassment and attacked the toothlessness of the Equal Employment Opportunity Law.

Housewives flexed their political muscle when they fought against a consumption tax. Their influence was credited with bringing down Prime Minister Uno, forced to resign when his mistress denounced him. His successor was quick to appoint two women to his cabinet.

In the late 1980s there were the highest number of female members of the legislature since World War II. It appeared that the number of women involved in politics was increasing every year.

The press raved about the Era of Women and the "Madonna boom." But all the political fireworks proved to be a flash in the pan. It was not long before the women cabinet members were replaced by men.

The 1996 Lower House elections showed gains for women, however. Twenty-three women, including Takako Doi, were elected to the 500-member Lower House, raising the percentage to 4.6 percent.

Women's voice in politics in Japan lags behind the rest of the world. The secretary-general of a U.N. conference on women has pointed out that the status of its female citizens does not match its economic status.

Women are not doing so well in American politics, either. Following the 1996 election there were nine female senators and 50 women in the House of Representatives.

One woman legislator believes that women in Japan are not succeeding in politics because it's a hereditary calling, passed down from father to son, just as in the tradition of kabuki theater.[1] Politics in Japan is considered a dirty business, too, as confirmed by the many scandals reported in the media. Women don't want to stoop to that level.[2]

One kind of public activity that has gained many enthusiasts among women in Japan is that of the community activist. Although women don't have the same clout as men in business and politics, they are the ones in control of environmental and consumer organizations. Because children are at the center of their lives, matters that protect the children's health and safety are much more socially acceptable than partisan politics. As Marilyn Inoue says, "A lot of those things, at least in our area, were only OK so long as they were revolving around home and family and children," but if you should tell your husband you're going to a political meeting, "that would be divorce city!"

Many women have embraced causes to improve the quality of their environment—from recycling and investigating the safety of food additives to applying

pressure on the government to bring about change. As women learn just how powerful they can be, they may use such movements as a springboard to further political activities.

Notes

Introduction

1. Names and certain details have been changed to maintain confidentiality. Please also note that Japanese names, here and throughout, have been rendered in the Western order, given name before family name.

1. The First Japanese in America

Epigraph: Richard Tames, *Encounters with Japan* (New York: St. Martin's, 1991), 125.

1. Foster Rhea Dulles, *Yankee and Samurai: America's Role in the Emergence of Modern Japan: 1791–1900* (New York: Harper, 1965), 48–49.

2. Tames, *Encounters with Japan*, 122.

3. Akiko Kuno, *Unexpected Destinations: The Poignant Story of Japan's First Vassar Graduate*, trans. Kirsten McIvor (Tokyo: Kodansha, 1993), 186.

4. Akemi Kikumura, *Through Harsh Winters: The Life of a Japanese Immigrant Woman* (Novato, CA: Chandler and Sharp, 1981), 96.

2. Problem of Today's Sojourners

1. David Everett, "Ambassador from Japan stays on diplomatic defensive," *Detroit Free Press*, 1 December 1991, G1.

2. John Lippert, "Japanese hear fewer cheers for U.S. plants," *Detroit Free Press*, 29 November 1991, A10.

3. Takashi "Tachi" Kiuchi, "Brushing up the image of Japanese in the States," *Japan Times Weekly International Edition*, 5–11 September 1994, 8.

4. Lisa W. Foderaro, "Japanese in New York Area Feel Sting of Prejudice," *New York Times*, 22 July 1990, midwestern edition, 20.

5. Jim Bohman, "Japan means jobs in Bellefontaine," *Dayton Daily News*, 9 February 1992, A12.

6. Jennifer Burkard Farkas, "Silent Suffering: The Dilemma of Japanese Families Residing Temporarily in America" (paper presented at the First National Conference on the Transcultural Family, Columbus, Ohio, 10–12 September 1984), 12.

7. Mary Eva Repass, "Adjustment and Adaptation of Japanese Wives in America," *Washington-Japan Journal*, winter 1992, 19.

8. Ryoko Fujii, "Christmas Eve on the Snowy Road," *Inscriptions* 13. (Dayton, Ohio: Dayton Christian Scribes, 1992), 27–30.

9. Merry White, *The Japanese Overseas: Can They Go Home Again?* (New York: Free Press, 1988), 64.

3. Household Managers

Epigraph: Gail Lee Bernstein, *Haruko's World: A Japanese Farm Woman and Her Community* (Stanford, CA: Stanford, University Press, 1983), 23.

1. Joy Hendry, "The Role of the Professional Housewife," in *Japanese Women Working*, ed. Janet Hunter (London:

Routledge, 1993) and Alan Roland, *In Search of Self in India and Japan: Toward a Cross-Cultural Psychology* (Princeton: Princeton University Press, 1988).

2. Sumiko Iwao, *The Japanese Woman: Traditional Image and Changing Reality* (New York: Free Press, 1993), 83.

3. Betty B. Lanham, "Ethics and Moral Precepts Taught in Schools of Japan and the United States," in *Japanese Culture and Behavior*, rev. ed., eds. Takie Sugiyama Lebra and William P. Lebra (Honolulu: University of Hawaii Press, 1986), 295.

4. Brian Moeran, "Individual, Group and *Seishin*: Japan's Internal Cultural Debate," in *Japanese Culture and Behavior*, rev. ed., eds. Takie Sugiyama Lebra and William P. Lebra (Honolulu: University of Hawaii Press, 1986), 65–66.

5. Iwao, *Japanese Woman*, 88.

6. Ibid, 3–4.

7. Rosalind C. Barnett, Grace K. Baruch, and Caryl Rivers, "The Secret of Self-Esteem," *Ladies' Home Journal*, February 1985, 54+.

8. Iwao, *Japanese Woman*, 84.

9. "Men with working wives make less, say studies," from Associated Press, *Dayton Daily News*, 14 October 1994, B11.

10. Deborah Fallows, "Japanese Women," *National Geographic*, April 1990, 66.

11. See Brenda Bankart, "Japanese Attitudes toward Women," *Journal of Psychology* 119.1 (1985):45–51; Millie R. Creighton, "Marriage, Motherhood, and Career Management in a Japanese 'Counter Culture,' " in *Re-Imaging Japanese Women*, ed. Anne E. Imamura (Berkeley: University of California Press, 1996), 205; and Takie Sugiyama Lebra, *Japanese Women: Constraint and Fulfillment* (Honolulu: University of Hawaii Press, 1984), 315.

12. James Trager, *Letters from Sachiko: A Japanese Woman's View of Life in the Land of the Economic Miracle* (New York: Atheneum, 1982), 130.

13. Miki Iwamura, et al., "A Comparative Analysis of Gender Roles and the Status of Women in Japan and the

United States," trans. Sue Y. Yang, *U.S.-Japan Women's Journal*, English Supplement 3 (1992): 38.

14. Chizuko Ueno, "The Position of Japanese Women Reconsidered," *Current Anthropology* 28:4 (1987): S80.

15. James Fallows, *Looking at the Sun: The Rise of the New East Asian Economic and Political System* (New York: Vintage/Random, 1994), 218.

4. Wives

Epigraph: Jane Condon, *A Half Step Behind: Japanese Women Today*, new ed. (Rutland, VT: Tuttle, 1991), 16.

1. Sumiko Iwao, *The Japanese Woman: Traditional Image and Changing Reality* (New York: Free Press, 1993), 100.

2. Ibid., 7.

3. Ibid., 69.

4. Bill Powell, "The Reluctant Princess," *Newsweek*, 24 May 1993, 28+.

5. Patrice Piquard, "La femme est l'avenir du japonais," *L'événement*, 6–12 August 1992, 67.

6. Iwao, *Japanese Woman*, 99, 100.

7. Ibid, 102.

8. Takie Sugiyama Lebra, *Japanese Women: Constraint and Fulfillment* (Honolulu: University of Hawaii Press, 1984), 271.

9. Gail Lee Bernstein, *Haruko's World: A Japanese Farm Woman and Her Community* (Stanford: Stanford University Press, 1983), 129.

10. "Workaholics they may be, Oriental Don Juans they ain't," *Japan Times Weekly International Edition*, 15–21 February 1993, 4.

11. Jared Taylor, *Shadows of the Rising Sun: A Critical View of the "Japanese Miracle"* (New York: William Morrow, 1983), 299.

5. Mothers

Epigraph: "The wisdom according to Ross," *Dayton Daily News*, 31 May 1992, B9.

1. Joy Hendry, "The Role of the Professional House-wife," in *Japanese Women Working*, ed. Janet Hunter (London: Routledge, 1993), 229.

2. Merry White, *The Japanese Educational Challenge: A Commitment to Children* (New York: Free Press, 1987), 12.

3. John Rosemond, "Mothers: Get out of children's lives," Knight Ridder News Service, *Dayton Daily News*, 29 April 1991.

4. It should be noted that the government has not neglected the father's role. The *Asahi Evening News* reports that the Ministry of Education is promoting fatherhood education, with lectures for fathers, Saturday sessions, and children's visits to the fathers' workplace.

5. Carol Simons, "They get by with a lot of help from their *kyoiku mamas*," *Smithsonian*, March 1987, 46.

6. Metamorphoses

Epigraph: Jun'ichiro Tanizaki, *Some Prefer Nettles*, intro. and trans. Edward G. Seidensticker (New York: Knopf, 1955), 142.

1. Robert L. Sharp, "Joe and Jane Salaryman keep Japan's wheel greased," *Japan Times Weekly International Edition*, 6–12 September 1993, 8.

2. Ibid.

3. Leila Philip, *The Road through Miyama* (New York: Random, 1989), 66.

4. Takie Sugiyama Lebra, *Japanese Women: Constraint and Fulfillment* (Honolulu: University of Hawaii Press, 1984), 278.

5. Robert J. Marra, "Social Relations as Capital: The Story of Yuriko," in *Re-Imaging Japanese Women*, ed. Anne E.

Imamura (Berkeley: University of California Press, 1966), 104–116.

6. Philip, *Road through Miyama*, 66.

7. Michael Hirsh, "The Agony and the Aftershock," *Newsweek*, international ed., 30 January 1995, 24.

7. Looking Back

1. Anne O. Freed, *The Changing Worlds of Older Women in Japan* (Manchester, CT: Knowledge, Ideas and Trends, 1993), 31.

2. Chizuko Ueno, "The Position of Japanese Women Reconsidered," *Current Anthropology* 28.4 (1987):577.

3. Anne Walthall, "The Life Cycle of Farm Women," in *Recreating Japanese Women: 1600–1945*, ed. and intro. Gail Lee Bernstein (Berkeley: University of California Press, 1991), 42–70.

4. Akiko Niwa, "The Formation of the Myth of Motherhood in Japan," trans. Tomiko Yoda, *U.S.-Japan Women's Journal*, English Supplement 4 (1993):76.

III. Women in Japan: The Public Sphere

Epigraph: James Trager, *Letters from Sachiko: A Japanese Woman's View of Life in the Land of the Economic Miracle* (New York: Atheneum, 1982), 133.

8. An Overview

1. "U.N. report calls women neglected," Associated Press, *Dayton Daily News*, 25 May 1993, A3.

2. Bill Powell, "The Reluctant Princess," *Newsweek*, 24 May 1993, 34.

3. Robert J. Saiget, "Japanese women seek a voice: Rights lag behind those in other industrialized nations,"

Kyodo News Service, *Japan Times Weekly International Edition*, 25 September–1 October 1995, 3.

4. United States, Department of Labor Report 96–291, 18 July 1996.

5. Kittredge Cherry, *Womansword: What Japanese Words Say about Women* (Tokyo: Kodansha, 1987), 47.

6. Carol Kleiman, "Mentoring program focuses on science," from *Chicago Tribune, Dayton Daily News*, 7 February 1994, 11.

7. Sumiko Iwao, *The Japanese Woman: Traditional Image and Changing Reality* (New York: Free Press, 1993), 159.

8. Alice Lam, "Equal Employment Opportunities for Japanese Women: Changing Company Practice," in *Japanese Women Working*, ed. Janet Hunter (London: Routledge, 1993), 221.

9. Deborah Fallows, "Japanese Women," *National Geographic* April 1990, 75.

10. Ibid., 76.

11. Kleiman, "Contingency: All the risks and no power," *Chicago Tribune, Dayton Daily News*, 5 September 1994, 14.

12. Paula Ries and Anne J. Stone, *The American Woman: 1992–1993* (New York and London: Norton, 1992), 436.

13. Betty Friedan, *The Feminine Mystique*, new ed. with new intro. and epilogue (New York: Norton, 1983), 17.

14. Urban Lehner and Kathryn Graven, "Quiet Revolution: Japanese Women Rise in their Workplaces, Challenging Tradition," *Wall Street Journal*, 6 September 1989, A1.

15. Susana Barciela, "Women climbing higher," Knight-Ridder News Service, *Dayton Daily News*, 3 August 1993, F1.

16. Kleiman, "Women-owned businesses are creating jobs," *Chicago Tribune, Dayton Daily News*, 6 April 1992, 11.

17. Ries and Stone, *American Woman*, 436.

18. Julius A. Roth, "Timetables and Lifecourse in Post-Industrial Society," in *Work and Lifecourse in Japan*, ed. David

W. Plath (Albany: State University of New York Press, 1983), 252.

9. The Young Single Woman

1. "Working women rise above 50% for the first time," trans. Reiko Lee, *Asahi Shinbun*, 5 September 1993.

2. Sumiko Iwao, *The Japanese Woman: Traditional Image and Changing Reality* (New York: Free Press, 1993), 166.

10. The Working Mother

1. Susan Chira, "Care at Child Day Centers is Rated as Poor," *New York Times*, 7 February 1995, midwestern ed., A6.

2. Carol Lutfy, "Investing in Working Mothers," *International Herald Tribune*, 22 June 1992, 9.

3. Kumiko Makihara, "Who Needs Equality?" *Time*, fall 1990, 36.

4. "Working women pinch birthrate," *Japan Times Weekly International Edition*, 24–30 June 1991, 20.

5. Bill Powell, "The Reluctant Princess," *Newsweek*, 24 May 1993, 34.

6. Marian Burros, "Even women in top-level jobs still shop, cook, clean, juggle," *New York Times* News Service, *Dayton Daily News*, 3 May 1993, A6.

11. The Career Woman

1. Kumiko Makihara, "Japanese Women: Rewriting Tradition," *Lear's* (February 1990):81.

2. Nancy Rivera Brooks, "Gender pay gap extends to highest levels," *Los Angeles Times*, *Buffalo News*, 2 July 1993, B18.

3. Sharman Stein, "Some women reject step to top rung," *Chicago Tribune, Dayton Daily News*, 28 May 1995, G4.

4. Japan, Ministry of Labor Report, trans. Reiko Lee, May 1993.

5. Alice Lam, "Equal Employment Opportunities for Japanese Women: Changing Company Practice," in *Japanese Women Working*, ed. Janet Hunter (London: Routledge, 1993), 217.

6. Millie R. Creighton, "Marriage, Motherhood and Career Management in a Japanese 'Counter Culture,'" in *Re-Imaging Japanese Women*, ed. and intro. Anne E. Imamura (Berkeley, University of California Press, 1996), 192–220.

7. Japan, Ministry of Labor Report.

8. Chie Nakane, "Women: A Cross-Cultural Perspective," *PHP*, February 1975, 6.

9. Andrew Mollison, "Pay Bias Still Exists," Cox News Service, *Dayton Daily News*, 6 June 1993, F6.

10. Makihara, "Japanese Women," 79.

11. Kittredge Cherry, *Womansword: What Japanese Words Say about Women* (Tokyo: Kodansha, 1987), 38.

12. Edwin M. Reingold, *Chrysanthemums and Thorns: The Untold Story of Modern Japan* (New York: St. Martin's, 1992), 101.

13. Asako Murakami, "Sexual harassment verdict viewed as landmark ruling," *Japan Times Weekly International Edition*, 18–24 May 1992, 4.

14. Sumiko Iwao, *The Japanese Woman: Traditional Image and Changing Reality* (New York: Free Press, 1993), 206.

15. Brooks, "Gender Pay Gap Extends to Highest Levels," B18.

12. Modern Times

1. Epigraph: Dorothy Robins-Mowry, *The Hidden Sun: Women of Modern Japan* (Boulder: Westview, 1983), 42.

2. Glenda Riley, *Inventing the American Woman: A Perspective on Women's History* (Arlington Heights, IL: Harlan Davidson, 1986), 95.

3. Mikiso Hane, *Modern Japan: A Historical Survey* (Boulder: Westview, 1983), 144.

4. Riley, *Inventing the American Woman*, 145.

5. Ibid.

6. Candace Falk, *Love, Anarchy and Emma Goldman*, rev. ed. (New Brunswick: Rutgers University Press, 1990), 9.

7. Robins-Mowry, *Hidden Sun*, 9.

8. Hane, *Reflections on the Way to the Gallows: Rebel Women in Prewar Japan* (Berkeley: University of California Press, 1991), 54.

9. Robins-Mowry, *Hidden Sun*, 82.

10. Gail Lee Bernstein, intro. and ed., *Recreating Japanese Women, 1600–1945* (Berkeley: University of California Press, 1991), 12.

11. Emiko Takenaka, "The Restructuring of the Female Labor Force in Japan in the 1980s," *U.S.-Japan Women's Journal*, English Supplement 2 (1992):4.

12. Hideko Takayama, "The Main Track at Last," *Newsweek*, 22 January 1990, 50.

13. Amy Borrus, "Look Whose Sun Is Rising Now: Career Women," *Business Week*, 25 August 1986, 50.

14. Urban Lehner and Kathryn Graven, "Quiet Revolution: Japanese Women Rise in their Workplaces, Challenging Tradition," *Wall Street Journal*, 6 September 1989. A1.

15. Carol Lutfy, "Investing in Working Mothers," *International Herald Tribune*, 22 June 1992, 9.

16. Lehner and Graven, "Quiet Revolution," A1.

17. "Work after marriage," *Japan Times Weekly International Edition*, 5–11 February 1990, 14.

16. Education

1. Anne Allison, "Producing Mothers," in *Re-Imaging Japanese Women*, ed. and intro. by Anne E. Imamura (Berkeley: University of California Press, 1996), 152.

2. Matthew Lowe, "Ghastly creatures all in a row," letter, *Japan Times Weekly International Edition*, 16–22 January 1995, 9.

17. American Women

1. Deborah Fallows, "Japanese Women," *National Geographic*, April 1990, 66.

2. Sumiko Iwao, *The Japanese Woman: Traditional Image and Changing Reality* (New York: Free Press, 1993), 11.

3. John R. Weisz, Fred M. Rothbaum, and Thomas C. Blackburn, "Standing Out and Standing In: The Psychology of Control in America and Japan," *American Psychologist*, September 1984, 955–69.

18. Connections

1. Jonathan Rauch, *The Outnation: A Search for the Soul of Japan* (Boston: Harvard Business School Press, 1992).

2. Sōseki Natsume, *I Am a Cat*, trans. Katsue Shibata and Motonari Kai (New York: Perigee-Putnam, 1961), 258.

Summing Up

Epigraph: Alan Roland, *In Search of Self in India and Japan: Toward a Cross-Cultural Psychology* (Princeton: Princeton University Press, 1988), xxviii.

1. Gary Althen, *American Ways: A Guide for Foreigners in the United States* (Yarmouth, Maine: Intercultural Press, 1988), 168.

2. Takie Sugiyama Lebra, *Japanese Women: Constraint and Fulfillment* (Honolulu: University of Hawaii Press, 1984), 3.

3. Kumiko Makihara, "Japanese Women: Rewriting Tradition," *Lear's*, February 1990, 78.

4. Millie R. Creighton, "Marriage, Motherhood, and Career Management in a Japanese 'Counter Culture,' " in *Re-Imaging Japanese Women*, ed. and intro. Anne E. Imamura (Berkeley: University of California Press 1996), 205.

5. Ichiro Ozawa, *Blueprint for a New Japan: The Rethinking of a Nation*, trans. Louise Rubinfein (Tokyo and New York: Kodansha, 1994), 156.

6. R. Taggart Murphy, *The Weight of the Yen* (New York: Norton, 1996), 54.

7. Betty Friedan, *The Second Stage* (New York: Summit, 1981), 17.

8. Susan Faludi, *Backlash: The Undeclared War against American Women* (New York: Crown, 1991), xv.

9. Steven A. Holmes, "Is This What Women Want?" *New York Times*, 15 December 1966, midwestern ed., K1+.

Appendix A

1. Mikiso Hane, *Reflections on the Way to the Gallows: Rebel Women in Prewar Japan* (Berkeley: University of California Press, 1988), 51.

2. Japan, Embassy, Japan Information and Culture Center, Note of 31 August 1994 on Ministry of Health and Welfare Report.

3. *Women in Medicine: Data Source* (Chicago: American Medical Association, 1993?).

4. Seekay Lan, "Nurses suffer burden of long, hard hours," *Japan Times Weekly International Edition*, 24–30 June 1991.

5. "Nurses stage nationwide walkout," *Japan Times Weekly International Edition*, 25 November–1 December 1991, 2.

6. Mary Saso, *Women in the Japanese Workplace* (London: Hilary Shipman, 1990), 63.

7. Claire LeBuffe, "Women in Engineering," *Engineering Workforce Bulletin*, May 1993.

8. "Women working in technical/engineering areas gather to exchange opinions," trans. Reiko Lee, *Asahi Shinbun*, 16 September 1993.

9. Hideko Takayama, "The Main Track at Last," *Newsweek*, 22 January 1990, 50.

10. Yoko Hayashi, "Women in the Legal Profession in Japan," *U.S.-Japan Women's Journal*, English Supplement 2 (1992).

11. Ibid.

12. Cynthia Fuchs Epstein, "It's still a tough climb for women in the law," *Dayton Daily News*, 1 August 1993, A7.

13. Japan, Embassy, Ministry of Health and Welfare Report. Note from Japan Information and Culture Center of 31 August 1994.

14. Ernest L. Boyer, Philip G. Altbach, Mary Jean Whitelaw, *The Academic Profession: An International Perspective* (Princeton, NJ: Carnegie Foundation for the Advancement of Teaching, 1994).

15. Louis Freedberg and Ramon G. McLeod, "Pay Gap Extends across Academia," *San Francisco Chronicle*, 5 November 1993, A1.

Appendix B

1. David E. Sanger, "The Career and the Kimono," *New York Times Magazine*, 30 May 1993, 29.

2. Sumiko Iwao, *The Japanese Woman: Traditional Image and Changing Reality* (New York: Free Press, 1993), 215.

References

"Ailing Japan economy cuts women's jobs." Associated Press. *Dayton Daily News*, 21 July 1992, C8.

Aita, Kaoruko. "Women must be patient: rights leader advocates." *Japan Times Weekly International Edition*, 27 November–3 December 1995, 16.

"Alliance seeks larger political role for women." *Japan Times Weekly International Edition*, 9–15 March 1992.

Allison, Anne. "Producing Mothers." In *Re-Imaging Japanese Women*, introduced and edited by Anne E. Imamura. Berkeley: University of California Press, 1996.

Altbach, Philip G. "Japanese professors give their jobs a mixed report card." *Japan Times Weekly International Edition*, 22–28 August 1994.

Althen, Gary. *American Ways: A Guide for Foreigners in the United States*. Yarmouth, Maine: Intercultural Press, 1988.

American Medical Association. *Women in Medicine in America*. Chicago: American Medical Association, 1991.

"Americans grow increasingly wary of Japan, survey shows." Kyodo News Service. *Japan Times Weekly International Edition*, 9–15 May 1994, 3.

Asseo, Laurie. "Women lawyers progress but still encounter

bias, pay inequality, report says." Associated Press. *Dayton Daily News*, 8 January 1996, A2.

Atanasov, Maria. "Ringing wedding refusal." *Fort Lauderdale Sun-Sentinal. Dayton Daily News*, 3 September 1993.

Bankart, Brenda. "Japanese Attitudes toward Women." *Journal of Psychology* 119.1 (1985): 45–51.

Barciela, Susana. "Women climbing higher." Knight-Ridder News Service. *Dayton Daily News*, 1 August 1993, F1.

Barnett, Rosalind C., Grace K. Baruch, and Caryl Rivers. "The Secret of Self-Esteem." *Ladies' Home Journal*, February 1985, 54+.

Bernstein, Gail Lee. *Haruko's World: A Japanese Farm Woman and her Community*. Stanford, CA: Stanford University Press, 1983.

———. Intro. and ed. *Recreating Japanese Women, 1600–1945*. Berkeley: University of California Press, 1991.

Bernstein, Nina. "Equal Opportunity Recedes for Most Female Lawyers." *New York Times* 8 January 1996, midwestern ed., A12.

Bohman, Jim. "Japan means jobs in Bellefontaine." *Dayton Daily News*, 9 February 1992, A1+.

Borrus, Amy. "Look Whose Sun Is Rising Now: Career Women." *Business Week*, 25 August 1986, 50.

Boyer, Ernest L., Philip G. Altbach and Mary Jean Whitelaw. *The Academic Profession: An International Perspective* Princeton, NJ: Carnegie Foundation for the Advancement of Teaching, 1994.

Brinton, Mary C. "The Social-Institutional Bases of Gender Stratification: Japan as an Illustrative Case." *American Journal of Sociology* 94 (1988): 300–34.

Brooks, Nancy Rivera. "Gender pay gap extends to highest levels." *Los Angeles Times. Buffalo News*, 2 July 1993, B13+.

Buckley, Jerry. " 'We Learned That Them May Be Us.' " *U.S. News and World Report*, 9 May 1988, 48–57.

Burros, Marian. "Even women in top-level jobs still shop, cook, clean, juggle." *New York Times* News Service. *Dayton Daily News*, 3 May 1993, A6.

"By the numbers." *Japan Times Weekly International Edition*, 20–26 September 1993, 17.

Caplan, Jane. Afterword. In *Recreating Japanese Women, 1600–1945*, edited by Gail Lee Bernstein. Berkeley: University of California Press, 1991, 315–21.

Carelli, Richard. "Women lawyers: We haven't come long way." Associated Press. *Dayton Daily News*, 13 February 1995, A1.

Caudill, William, and Helen Weinstein. "Maternal Care and Infant Behavior in Japan and America." In *Japanese Culture and Behavior*, rev. ed., edited by Takie Sugiyama Lebra and William P. Lebra. Honolulu: University of Hawaii Press, 1986, 201–246.

"The changing color of marriage: mixed couples on rise." *Japan Times Weekly International Edition*, 3–9 October 1994, 20.

Cherry, Kittredge. *Womansword: What Japanese Words Say about Women.* Tokyo: Kodansha, 1987.

Chira, Susan. "Care at Child Day Centers Is Rated as Poor." *New York Times*, 7 February 1995, midwestern ed., A6.

———. "Thoroughly Modern Masako." *Lear's*, June 1993, 58+.

Christopher, Robert C. *The Japanese Mind.* New York: Fawcett-Columbine, 1983.

"Classes may help harried fathers." *Asahi Evening News*, 6 October 1993.

Condon, Jane. *A Half Step Behind: Japanese Women Today*, new ed. Rutland, VT: Tuttle, 1991.

Coulmas, Florian. "Equal before the law, women remain Japan's second sex." Review of *Management: Discrimination and Reform*, by Alice C. L. Lam. *Japan Times Weekly International Edition*, 22–28 March 1993, 18.

Creighton, Millie R. "Marriage, Motherhood, and Career Man-

agement in a Japanese 'Counter Culture.' " In *Re-Imaging Japanese Women*, introduced and edited by Anne E. Imamura. Berkeley: University of California Press, 1996, 192–220.

"Crown Prince Naruhito and Masako Owada: the Owada story." *Japan Times Weekly International Edition*, 18–24 January 1993, 10–11.

Diggs, Nancy. *Meet the Japanese*. Columbus, OH: Renaissance, 1991.

——— and Brian Murphy. "Japanese Adjustment to American Communities: The Case of the Japanese in the Dayton Area." *International Journal of Intercultural Relations* 15 (1991): 103–116.

Dore, Ronald. Foreword. *Women in the Japanese Workplace*. By Mary Saso. London: Hilary Shipman, 1990, vii–xi.

Duffy, Martin. "The 21st Century Princess." *Time*, 7 June 1993, 54–58.

Dulles, Foster Rhea. *Yankee and Samurai: America's Role in the Emergence of Modern Japan: 1791–1900*. New York: Harper, 1965.

Ehara, Yumiko. "Japanese Feminism in the 1970s–1980s." Trans. Eino Yanagida and Paul Long. In *U.S.-Japan Women's Journal*. English Supplement 4 (1993): 49–69.

Ehrenreich, Barbara. "What Do Women Have to Celebrate?" *Time*, 16 November 1992, 61–62.

Epstein, Cynthia Fuchs. "It's still a tough climb for women in the law." *Dayton Daily News*, 2 August 1993, A7.

Everett, David. "Ambassador from Japan stays on diplomatic defensive." *Detroit Free Press*, 1 December 1991, 1G.

Falk, Candace. *Love, Anarchy and Emma Goldman*, rev. ed. New Brunswick: Rutgers University Press, 1990.

Fallows, Deborah. "Japanese Women." *National Geographic*, April 1990, 52–82.

Fallows, James. *Looking at the Sun: The Rise of the New East*

Asian Economic and Political System. New York: Vintage/Random, 1994.

Faludi, Susan. *Backlash: The Undeclared War against American Women.* New York: Crown, 1991.

Farkas, Jennifer Burkard. "Japanese Overseas Children's American Schooling Experience: A Study of Cross-Cultural Transition." Ph.D. diss., Ohio State University, 1983.

————. "A Qualitative Approach to Cross-Cultural Education: Acculturation of Japanese Returnees." Paper presented at 1991 Annual Meeting of the American Educational Research Association. Chicago, IL. 4–7 April 1991.

————. "Silent Suffering: The Dilemma of Japanese Families Residing Temporarily in America." Paper presented at the First National Conference on the Transcultural Family. Columbus, OH. 10–12 September 1984.

"Female workers still face job bias: government report." Kyodo News Service. *Japan Times Weekly International Edition,* 25–31 December 1995, 12.

"Few women yet in government." Kyodo News Service. *Japan Times Weekly International Edition,* 19–25 December 1994, 4.

Field, Norma. *In the Realm of a Dying Emperor.* New York: Random, 1991.

Fisher, Helen. Lecture at Chautauqua Institution, Chautauqua, NY, 1990.

Foderaro, Lisa W. "Japanese in New York Area Feel Sting of Prejudice." *New York Times,* 22 July 1990, midwestern ed., 20.

Freed, Anne O. *The Changing Worlds of Older Women in Japan.* Manchester, CT: Knowledge, Ideas and Trends, 1993.

Freedberg, Louis, and Ramon G. McLeod. "Pay Gap between Sexes Extends across Academia." *San Francisco Chronicle,* 5 November 1993, A1+.

Friedan, Betty. *The Feminine Mystique*, new ed. New York: Norton, 1983.

———. *The Second Stage*. New York: Summit, 1981.

Fucini, Joseph J., and Suzy Fucini. *Working for the Japanese: Inside Mazda's American Automobile Plant*. New York: Free Press, 1990.

Fujii, Ryoko. "Christmas Eve on the Snowy Road." *Inscriptions* 13. Dayton, Ohio: Dayton Christian Scribes, 1992, 27–30.

Gelsenliter, David. *Jump Start: Japan Comes to the Heartland.* New York: Harper, 1990.

Graven, Kathryn. "The Home Front: Japanese Housewives Grow More Resentful of Executive Spouses." *Wall Street Journal*, 30 September 1987, 1+.

Hamura, Shōtaro. "Some Social, Political, and Legal Aspects in Japan." *The Bulletin of the Okayama University of Science*, 28 September 1992: 289–301.

Hane, Mikiso. *Reflections on the Way to the Gallows: Rebel Women in Prewar Japan.* Berkeley: University of California Press, 1988.

Hani, Yoko. " 'Railway station nurseries' help commuting moms." *Japan Times Weekly International Edition*, 15–21 May 1995, 16.

———. "Women job-seekers battle slump, sexism." *Japan Times Weekly International Edition*, 23–29 May 1994, 7.

Harris, Diane. "Salary Survey 1995." *Working Woman*, January 1995, 25–34.

Hayashi, Yoko, "Women in the Legal Profession in Japan." *U.S.-Japan Women's Journal.* English Supplement 2 (1992): 16–27.

Hendry, Joy. "The Role of the Professional Housewife." *Japanese Women Working*, edited by Janet Hunter. London: Routledge, 1983, 224–241.

Hirsh, Mirchael. "The Agony and the Aftershock." *Newsweek*, 30 January 1995, international edition, 20–25.

Holden, Karen C. "Changing Employment Patterns of Women." *Work and Lifecourse in Japan*, edited by David W. Plath. Albany: State University of New York Press, 1983.

Holmes, Stephen A. "Is This What Women Want?" *New York Times*, 15 December 1996, midwestern ed., K1+.

————. "Programs Based on Sex and Race Are under Attack." *New York Times*, 16 March 1995, midwestern ed., A1.

Hunter, Janet, ed. and intro. *Japanese Women Working*. London: Routledge, 1993.

Imamura, Anne, ed. *Re-Imaging Japanese Women*. Berkeley: University of California Press, 1996.

————. *Urban Japanese Housewives: At Home and in the Community*. Honolulu: University of Hawaii Press, 1987.

Impoco, Jim. "Motherhood and the Future of Japan." *U.S. News and World Report*, 24 December 1990, 56–57.

" 'In the old days, women were hard workers,' " trans. Reiko Lee. *Asahi Shinbun*, 14 September 1993.

"Influx of Japanese Changing Style of Midwest." *New York Times*, 15 February 1987, A1+.

Itoi, Kay, and Bill Powell. "Take a Hike, Hiroshi." *Newsweek*, 10 August 1992, 38–39.

Iwamura, Miki, Atsuko Kunishige, Hiroshi Tanaka, Emiko Tomie, and Itsuki Yamamoto. "A Comparative Analysis of Gender Roles and the Status of Women in Japan and the United States," translated by Sue Y. Yang. *U.S.-Japan Women's Journal*. English Supplement 3 (1992): 36–53.

Iwao, Sumiko. *The Japanese Woman: Traditional Image and Changing Reality*. New York: Free Press, 1993.

Jackson, Maggie. "Top positions sparse for women." Associated Press. *Dayton Daily News*, 18 October 1996, B7.

"JAL to hire first woman pilot." *Japan Times Weekly International Edition*, 8–14 August 1994.

Japan. Embassy: Japan Information and Culture Center, Note

of 31 August 1994 on Ministry of Health and Welfare Report.

———. Embassy: Telephone conversations of 28 July 1993 and 28 January 1994.

———. Ministry of Labor Report, translated by Reiko Lee. May 1993.

"Japanese prime minister names cabinet." Associated Press. *Dayton Daily News*, 9 August 1993.

"Japanese women: a world apart." *The Economist*, 14 May 1988, 19–21.

"Japan's first spacewoman lifts off." *Japan Times Weekly International Edition*, 18–24 July 1994, 2.

Johnson, Sheila K. *The Japanese through American Eyes*. Stanford, CA: Stanford University Press, 1988.

Jones, Sarah Beth. "The Glass Ceiling Effect." *Network*, summer 1992, 47–48.

Joy, Ted. "In Troy, the welcome mat to Japan is out." *Magazine of the Beacon Journal* (Akron, Ohio), 4 March 1990, 4+.

Kamogawa, Kazuko. Conversation of 13 October 1993.

Kanda, Mikeo, ed. *Widows of Hiroshima: The Life Stories of Nineteen Peasant Women*, translated by Taeko Midorikawa. New York: St. Martin's, 1982.

Kiefer, Christie W. "The Psychological Interdependence of Family, School, and Bureaucracy in Japan." *American Anthropologist* 72 (1970): 66–75.

Kikumura, Akemi. *Through Harsh Winters: The Life of a Japanese Immigrant Woman*. Novato, CA: Chandler and Sharp, 1981.

Kilborn, Peter P. "Women and Minorities Still Face 'Glass Ceiling.'" *New York Times*, 16 March 1995, midwestern ed., C22.

King, Laura. "Woman gains post." Associated Press. *Dayton Daily News*, 7 August 1993, A3.

Kitano, Harry H. L. "Inter- and Intragenerational Differences in Maternal Attitudes towards Child Rearing." *Journal of Social Psychology* 63 (1964):215–220.

Kiuchi, Takashi "Tachi." "Brushing up the image of Japanese in the States." *Japan Times Weekly International Edition* 5–11 September 1994, 8.

Kleiman, Carol. "Contingency: All the risks and no power." *Chicago Tribune. Dayton Daily News*, 5 September 1994, 14.

———. "Japanese, U.S. women share workplace problems." *Chicago Tribune. Dayton Daily News*, 12 March 1990, 6.

———. "Mentoring program focuses on science." *Chicago Tribune. Dayton Daily News*, 7 February 1994, 11.

———. "Study finds men working less around the home." *Chicago Tribune. Dayton Daily News*, 1 August 1994, 9.

———. "Women-owned businesses are creating jobs." *Chicago Tribune. Dayton Daily News*, 6 April 1992, 11.

Koch, Elenore A. Professor of Comparative Sociology, Kibi International University, Okayama, Japan. Interview of 19 August 1993.

Koyama, Shizuko. "The 'Good Wife and Wise Mother' Ideology in Post-World War I Japan." *U.S.-Japan Women's Journal.* English Supplement 7 (1993): 31–51.

Kumagai, Fumie. "The Life Cycle of the Japanese Family." *Journal of Marriage and the Family* 46.1 (1984): 191–204.

Kuno, Akiko. *Unexpected Destinations: The Poignant Story of Japan's First Vassar Graduate.* Translated by Kirsten McIvor. Tokyo: Kodansha, 1993.

Lam, Alice. "Equal Employment Opportunities for Japanese Women: Changing Company Practice." In *Japanese Women Working,* edited by Janet Hunter. London: Routledge, 1993, 197–221.

Lan, Seekay. "Nurses suffer burden of long, hard hours." *Japan Times Weekly International Edition,* 24–30 June 1991.

Lanham, Betty B. "Ethics and Moral Precepts Taught in Schools of Japan and the United States." In *Japanese Culture and Behavior*, rev. ed., edited by Takie Sugiyama Lebra and William P. Lebra. Honolulu: University of Hawaii Press, 1986.

Lavan, Rosemary Metzler. "Women execs glum." *New York Daily News. Dayton Daily News* 24 November 1993.

Lebra, Takie Sugiyama. "Fractionated Motherhood: Status and Gender among the Japanese Elite." *U.S.-Japan Women's Journal.* English Supplement 4 (1993): 3–25.

———. *Japanese Patterns of Behavior.* Honolulu: University of Hawaii Press, 1976.

———. *Japanese Women: Constraint and Fulfillment.* Honolulu: University of Hawaii Press, 1984.

——— and William P. Lebra, eds. *Japanese Culture and Behavior*, rev. ed. Honolulu: University of Hawaii Press, 1986.

LeBuffe, Claire. "Women in Engineering." *Engineering Workforce Bulletin*, May 1993.

Lehner, Urban and Kathryn Graven. "Quiet Revolution: Japanese Women Rise in their Workplaces, Challenging Tradition." *Wall Street Journal*, 6 September 1989, A1+.

Lindsley, Evangeline. Interviews of 29 January 1992 and 16 September 1993.

Lippert, John. "Japanese hear fewer cheers for U.S. plants." *Detroit Free Press*, 29 November 1991, A1+.

———. "Mazda family savors experiences." *Detroit Free Press*, 28 November 1991: A1+.

Lowe, Matthew. "Ghastly creatures all in a row." Letter. *Japan Times Weekly International Edition*, 16–22 January 1995, 9.

Lutfy, Carol. "Investing in Working Mothers.: *International Herald Tribune*, 22 June 1992, 9.

Makihara, Kumiko. "Japanese Women: Rewriting Tradition." *Lear's*, February 1990, 78–83.

————. "Who Needs Equality?" *Time*, fall 1990, 35–36.

Marden, C. F. and G. Meyer. *Minorities in American Society*. New York: D. Nostrand, 1973.

Marra, Robert J. "Social Relations as Capital: The Story of Yuriko." In *Re-Imaging Japanese Women*, edited by Anne E. Imamura. Berkeley: University of California Press, 1996.

Marsella, Anthony J., George DeVos, and Francis L. L. Ksu, eds. *Culture and Self: Asian and Western Perspectives*. New York and London: Tavistock, 1985.

Martinez, D. P. comment on "Position of Japanese Women Reconsidered," by Chizuko Ueno. *Current Anthropology* 28.4 (1987): S82–84.

Maruyama, Mayumi. "Living in Japan divorced with kids is no easy task." *Asahi Evening News*, 31 August 1994, 9.

"Men with working wives make less, say studies." Associated Press. *Dayton Daily News* 14 October 1994, B11.

McLendon, James. "The Office: Way Station or Blind Alley?" In *Work and Lifecourse in Japan*, edited by David W. Plath. Albany: State University of New York Press, 1983, 156–182.

"Middle-aged couples stay close by living separately." *Asahi Evening News*, 13 October 1994.

Mincer, Jillian. "Boys Get Called On." *New York Times Education Life*, 9 January 1994, 27.

Miyake, Yoshiko. "Doubling Expectations: Motherhood and Women's Factory Work under State Management in Japan in the 1930s and 1940s." In *Recreating Japanese Women*, edited by Gail Lee Bernstein. Berkeley: University of California Press, 1991, 267–295.

Mockrish, Robert. Principal of the Middle School of the Canadian Academy, Kobe, Japan. Interview of 5 October 1993.

Moeran, Brian. "Individual, Group and *Seishin*: Japan's Internal Cultural Debate." In *Japanese Culture and Behavior*, rev. ed., edited by Takie Sugiyama Lebra and

William P. Lebra. Honolulu: University of Hawaii Press, 1986, 62–79.

Mollison, Andrew. "Pay bias still exists." Cox News Service. *Dayton Daily News*, 6 June 1993, F1+.

"More Japanese give preference to private life over work." Kyodo News Service. *Japan Times Weekly International Edition*, 22–28 August 1994, 6.

Murakami, Asako. "Politics loses some of its 'Madonna' touch." *Japan Times Weekly International Edition*, 10–16 August 1992, 4.

———. "Sexual Harassment verdict viewed as landmark ruling," *Japan Times Weekly International Edition*, 18–24 May 1992, 4.

Muramoto, Kumiko, Psychologist and ed., *Feminine Life Cycle*, Kyoto, Japan. Interview of 3 October 1993.

Murphy, R. Taggart. *The Weight of the Yen.* New York: Norton, 1996.

Naito, Yuko. "Caught in the crunch." *Japan Times Weekly International Edition*, 30 August–5 September 1993, 10–11.

Nakamura, Akemi. "Perverts hiding in plain sight in commuter trains." *Japan Times Weekly International Edition.* 24–30 July 1995, 16.

Nakamura, Yoko. "Harue Kitamura: Japan's first female mayor brings own style to office." *Japan Times Weekly International Edition* 22–28 July 1991: 1+.

Nakane, Chie. *Japanese Society.* Berkeley: University of California Press, 1970.

———. "Women" A Cross-Cultural Perspective." *PHP*, February 1975, 2–12.

Narisetti, Raju. "Women cracking glass ceiling?" *Dayton Daily News*, 17 November 1993, A1+.

Nashima, Mitsuko. "Behind closed doors." *Japan Times Weekly International Edition*, 13–19 June 1994, 7.

Natsume, Sōseki. *I Am a Cat*. Trans. Katsue Shibata and Motonari Kai. New York: Perigee-Putnam, 1961.

"Newsmaker: Makiko Tanaka." *Japan Times Weekly International Edition*, 18–24 July 1994, 17.

Niwa, Akiko. "The Formation of the Myth of Motherhood in Japan." Translated by Tomiko Yoda. *U.S.-Japan Women's Journal* English Supplement 4 (1993): 70–82.

Noguchi, Mary Goebel. "The Rise of the Housewife Activist." *Japan Quarterly* 39.3 (July–September 1992): 339–352.

"Nomura women feel the pinch." *Japan Times Weekly International Edition*, 20–26 July 1992, 21.

"Nurses stage nationwide walkout." *Japan Times Weekly International Edition*, 25 November–1 December, 1991, 2.

"Ogata honored for refugee aid." *Japan Times Weekly International Edition*, 2–8 May 1994, 2.

Oikawa, Miu. "Royal romance spotlights changing view of marriage." *Japan Times Weekly International Edition* 10–16 May 1992, 4.

Orenstein, Peggy and the American Association of University Women. *School Girls, Young Women, Self-Esteem, and the Confidence Gap*. New York: Doubleday, 1994.

Osawa, Mari. "Corporate-Centered Society and Women's Labor in Japan Today." Translated by Scott Callon. *U.S.-Japan Women's Journal*. English Supplement 3 (1992): 3–35.

"Our view of marriage must change." Editorial. *Japan Times Weekly International Edition*, 16–22 May 1994, 20.

Ozawa, Ichiro. *Blueprint for a New Japan: The Rethinking of a Nation*. Translated by Louise Rubinfein. Tokyo and New York: Kodansha, 1994.

Philip, Leila. *The Road through Miyama*. New York: Random 1989.

Piquard, Patrice. "La femme est l'avenir du japonais." *L'événement*, 6–12 August 1992, 66–67.

Plath, David W., ed. *Work and Lifecourse in Japan*. Albany: State University of New York Press, 1983.

"Plus Ça Change: The Annual Report on the Economic Status of the Profession, 1993–94." *Academe* (Bulletin of the American Association of University Professors) (March/April 1994):80:2, 5–89.

Post, Kim. "She Said . . . He Said: Gender Differences." Lecture to Women's Club, Chautauqua, NY, 1993. Tape 8 Chautauqua 93–183.

Powell, Bill. "The Reluctant Princess." *Newsweek*, 24 May 1993, 28+.

"Psychotherapy East and West: Japan and America." Seminar sponsored by the Union Institute. Convened by Drs. Robert McAndrews and Shigemasa Aoki. Kyoto, Japan, 1–5 October 1993.

Raffalli, Mary. "Why So Few Women Physicists?" *New York Times Education Life* 9 January 1994, 28+.

Rauch, Jonathan. *The Outnation: A Search for the Soul of Japan.* Boston: Harvard Business School Press, 1992.

Reid, T. R. "In Japan's singles scene, women rule." *Washington Post* 17 September 1993, A1+.

Reingold, Edwin M. *Chrysanthemums and Thorns: The Untold Story of Modern Japan.* New York: St. Martin's, 1992.

Repass, Mary Eva. "Adjustment and Adaptation of Japanese Wives in America." *Washington-Japan Journal*, winter 1992, 19–22.

Ries, Paula, and Anne J. Stone. *The American Woman: 1992–1993.* New York and London: Norton, 1992.

"Rights leader hits Japan on women." *Japan Times Weekly International Edition*, 18 October 1993.

Riley, Glenda. *Inventing the American Woman: A Perspective on Women's History* (Arlington Heights, IL: Harlan Davidson, 1986).

Robins-Mowry, Dorothy. *The Hidden Sun: Women of Modern Japan.* Boulder: Westview, 1983.

Roland, Alan. *In Search of Self in India and Japan: Toward a*

Cross-Cultural Psychology. Princeton: Princeton University Press, 1988.

Rosemond, John. "Mothers: Get out of children's lives." Knight-Ridder News Service. *Dayton Daily News*, 29 April 1991.

Roth, Julius A. "Timetables and Lifecourse in Post-Industrial Society." In *Work and Lifecourse in Japan*, edited by David W. Plath. Albany: State University of New York Press, 1983.

Rudolph, Ellen. "On Language: Women's Talk." *New York Times Magazine*, 1 September 1991, 8.

Runyon, Keith L. "Japan: slow, but sure changes for women." *Louisville Courier-Journal*, 28 October 1993, 2.

Saiget, Robert J. "Japanese women seek a voice: Rights lag behind those in other industrial nations." Kyodo News Service. *Japan Times Weekly International Edition*, 25 September–1 October 1995, 3.

Salamon, Sonya. " 'Male Chauvinism' as a Manifestation of Love in Marriage." In *Japanese Culture and Behavior*, rev. ed., edited by Takie Sugiyama and William P. Lebra. Honolulu: University of Hawaii Press, 1986, 130–141.

Sanger, David E. "The Career and the Kimono." *New York Times Magazine*, 30 May 1993, 18+.

———. "Job-Seeking Women in Japan Finding More Discrimination." *New York Times*. International Edition, 27 May 1994, A9.

Saso, Mary. *Women in the Japanese Workplace*. London: Hilary Shipman, 1990.

Sato, Kyoko. "Low-paid women count the cost of equality battle." *Japan Times Weekly International Edition*, 6–12 June 1994, 7.

———. "Sexual stereotypes derail career women." *Japan Times Weekly International Edition*, 30 May–5 June 1994, 17.

————. "Wife, mother, housekeeper, servant." *Japan Times Weekly International Edition*, 14–20 August 1995, 7.

Schwartz, John. "The 'Salaryman' Blues." *Newsweek*, 9 May 1988, 51–52.

Sharp, Robert L. "Joe and Jane Salaryman keep Japan's wheel greased." *Japan Times Weekly International Edition*, 6–12 September 1993, 8.

Shibamoto, Janet S. *Japanese Women's Language*. Orlando, FL: Academic Press, 1985.

Silverberg, Miriam. "The Modern Girl as Militant." In *Recreating Japanese Women, 1600–1945*, edited by Gail Lee Bernstein. Berkeley: University of California Press, 1991, 239–266.

Simons, Carol. "They get by with a lot of help from their *kyoiku mamas*." *Smithsonian*, March 1987, 44–53.

Stein, Sharman. "Some women reject step to top rung." From *Chicago Tribune*. *Dayton Daily News*, 28 May 1995, G4.

Sterngold, James. "A Feminist Politician in Tokyo Uses Anger and Pranks to Battle Despair." *New York Times*, 14 March 1993, E7.

"Students flock to job meeting: Small firms draw scores of desperate job-seekers." *Japan Times*, 8 October 1993.

"Study finds women still lag." Associated Press. *Dayton Daily News*, 15 June 1993, B4.

Superville, Darlene. Associated Press. "Diversity stops at top, glass-ceiling study says." *Dayton Daily News*, 16 March 1995, A5.

Takayama, Hideko. "The Main Track at Last." *Newsweek*, 22 January 1990, 50–51.

Takenaka, Emiko. "The Restructuring of the Female Labor Force in Japan in the 1980s." *U.S.-Japan Women's Journal*. English Supplement 2 (1992): 3–15.

Takenobu, Mieko. "Problems with divorce law changes." *Asahi Evening News*, 26 October 1994, 9.

Tames, Richard. *Encounters with Japan*. New York: St. Martin's, 1991.

Tanaka, Rieko. "Woman executive chides condescending industries." *Japan Times Weekly International Edition*, 16–22 November 1992, 4.

Tanizaki, Jun'ichiro. *Some Prefer Nettles*. Introduced and translated by Edward G. Seidensticker. New York: Knopf, 1955.

Tannen, Deborah. *Talking from 9 to 5: How Women's and Men's Conversational Styles Affect Who Gets Heard, Who Gets Credit, and What Gets Done at Work*. New York: Morrow, 1994.

————. *You Just Don't Understand: Women and Men in Conversation*. New York: Morrow, 1990.

Tasker, Peter. *The Japanese: A Major Exploration of Modern Japan*. New York: Dutton, 1987.

Taylor, Jared. *Shadows of the Rising Sun: A Critical View of the "Japanese Miracle."* New York: Morrow, 1983.

Trager, James. *Letters from Sachiko: A Japanese Woman's View of Life in the Land of the Economic Miracle*. New York: Atheneum, 1982.

24% of elementary, 60% of junior high kids go to cram schools." *Japan Times Weekly International Edition*, 5–11 September 1994, 7.

"U.N. report calls women neglected." Associated Press. *Dayton Daily News*, 25 May 1993, A3.

Ueno, Chizuko. "The Position of Japanese Women Reconsidered." *Current Anthropology* 28.4 (1987):S75–84.

United States. Department of Labor Report 96–291. 18 July 1996.

————. "Employment in Perspective: Women in the Labor Force." 1st Quarter 1994. U.S. Dept. of Labor Bureau of Labor Statistics. Report 872.

————. "Labor Force Statistics from the Current Population Survey," 24 Jan. 1997

<http://stats/bls/gov/news.release/wkyeng.t08.htm> (31 March 1997).

VanWolferen, Karel. "Japan's Non-Revolution." *Foreign Affairs* 72.4 (1993): 54–65.

Wakita, Haruko. "Women and the Creation of the *Ie* in Japan: An Overview from the Medieval Period to the Present." Translated by David P. Phillips. *U.S.-Japan Women's Journal.* English Supplement 4 (1993): 83–105.

Walker, Juliette. "Kids returning from abroad belong to 'third culture.' " *Japan Times Weekly International Edition,* 18–24 March 1991, 7.

Walthall, Anne. "The Life Cycle of Farm Women." In *Recreating Japanese Women: 1600–1945.* Introduced and edited by Gail Lee Bernstein. Berkeley: University of California Press, 1991, 42–70.

Weisman, Steven R. "In Crowded Japan, a Bonus for Babies Angers Women." *New York Times,* 17 February 1991, 1+.

Weisz, John R., Fred M. Rothbaum, and Thomas C. Blackburn, "Standing Out and Standing In: The Psychology of Control in America and Japan." *American Psychologist,* September 1984, 955–969.

White, Merry. *The Japanese Educational Challenge: A Commitment to Children.* New York: Free Press, 1987.

———. *The Japanese Overseas: Can They Go Home Again?* New York: Free Press, 1988.

Wiley, Peter Booth, and Korogi Ichiro. *Yankee in the Land of the Gods: Commodore Perry and the Opening of Japan.* New York: Viking, 1990.

Wilson, Robert A. and Bill Hosokawa. *East to America: A History of the Japanese in the United States.* New York: Morrow, 1980.

"The wisdom according to Ross." *Dayton Daily News,* 31 May 1992, B9.

Women in Medicine: Data Source. Chicago: American Medical Association, 1993?.

"Women legislator says equality law does not need teeth." *Japan Times Weekly International Edition*, 21–17 March 1994, 4.

"Women moving up in Japan businesses slowly and surely." *New York Times* News Service. *Dayton Daily News*, 11 December 1988.

"Women see job inequality, stress." Associated Press. *Dayton Daily News*, 15 October 1994, A5.

"Women working in technical/engineering areas gather to exchange opinions." Translated by Reiko Lee. *Asahi Shinbun*, 16 September 1993.

"Women's participation in politics, administration and justice administration still low." Translated by Reiko Lee. *Asahi Shinbun*, 2 August 1993.

"Work after marriage." *Japan Times Weekly International Edition*, 5–11 February 1990, 14.

"Workaholics they may be, Oriental Don Juans they ain't." *Japan Times Weekly International Edition*, 15–21 February 1993, 4.

"Working women pinch birthrate." *Japan Times Weekly International Edition*, 24–30 June 1991, 20.

"Working women rise above 50% for the first time." Translated by Reiko Lee. *Asahi Shinbun*, 5 September 1993.

Yoshida, Reiji. "Working mothers rap public day-care centers' short hours." *Japan Times Weekly International Edition*, 29 November–5 December 1993, 7.

Index

Alliance of Feminist Representatives, 105
Allison, Anne, 131
Althen, Gary, 151
Amae. See Dependence
American Equal Rights Association, 100
American influence on Japanese, 102, 103–04, 106, 107, 128, 135
American people, Japanese views of, 10, 34, 137–43, 145–48, 151–52
American women, 33–34, 35, 36, 37, 38, 43, 49–50, 81, 124, 137–43, 153
 mothers, 52, 54–55, 138, 139–40
 See also Employment, female, in United States; Education in United States: for women; Feminism in United States
Anthony, Susan B., 100
Arranged marriages, 43
Authority. *See* power/control
Azumo, Tomoko, 105

Bernstein, Gail Lee, 31, 45, 103

Birth rate, 76, 78, 79, 105
Bluestocking Society, 99
Buddhism, 33, 34, 145
Business Week, 104
Businessmen in Japan, 25, 36, 49, 66, 67, 106, 123–24, 153, 154, 155

California Alien Land Laws, 14
"Catalog Generation," 47
Change, 104–07, 154–55
 of sojourners, 128
 in United States, 154
Cherry, Kittredge, 90
Child care, 79, 81, 84
Children
 dependence on mothers, 47–48, 51, 134–45, 152
 education, 20–21, 23–25, 55–57, 131–35
 mother's responsibility for, 35, 49–53
 problems, 20–25
Chin, Vincent, 18
Communication
 between spouses, 43–45, 119
 in United States, 19, 20, 111
 See also Language
Condon, Jane, 41

Conformity, 11, 22–24, 26, 36, 39–40, 41, 53, 54, 121–29, 131–35, 148, 152, 153, 154
Confucianism, 32–33, 36, 41, 55, 74
Control. *See* Power/Control
Creighton, Millie R., 85, 153

Dependence
 of children on mothers, 47–48, 51, 134–45, 152
 of husband on wife, 47–48
Depression years, 101
Divorce, 5, 44–45, 46, 125, 141–42
Doi, Koka, 96
Doi, Takako, 83, 91, 105, 161, 162

Early immigrants, 9–15
 loyalties of, 12–14
 restrictions on, 11, 14
Education in Japan, 20–21, 23–25, 55–57
 adult, 124, 157
 differences in boys' and girls', 55–57, 72–73
 dissatisfaction with, 131–35
 expenses, 80
 of sojourners, 20–21, 24, 56, 64, 72, 112, 113
 for women in historical times, 95–96
 See also Children: education
Education in United States, 21, 56, 72–73, 131, 132–35
 for adults, 124
 for women, 72–73, 96
Employment, female, in Japan, 39, 71–93
 academic, 159
 agricultural, 76
 career women, 39, 83–93, 103, 154
 conditions, 71, 75, 81, 97, 101, 104, 106, 155

discrimination, 71–75, 83, 84–86, 87–88, 93, 104, 154, 158, 159
 engineers, 91, 158
 entrepreneurs, 76
 foreign companies, 73–74
 industrial, 97, 100, 102, 103
 informal sector, 75–76
 "integrated"/"general" career paths, 86–88
 lawyers, 158–59
 in medicine, 157–58
 "office ladies" (OLs), 72, 77–78, 86–87, 112
 part-time, 39, 73, 74–75, 81
 pay, compared to male, 71–72
 postwar period, 102
 ratio of male to female, 71
 recruitment, 84–85
 seniority, 74, 76
 small businesses, 73
 sōgōshoku/ippan. See Integrated"/"general" career paths
 Taishō period, 100–01
 working mothers, 79–80, 84
 World War II, 102
Employment, female, in United States, 74, 75, 76, 83, 88–90, 97, 101, 154
 academic, 159
 agricultural, 76
 engineers, 158
 lawyers, 159
 in medicine, 157
 part-time, 75
 pay, compared to male, 72
 ratio of male to female, 71
 small businesses, 73, 76
 working mothers, 79, 83
Endurance, 63, 143, 152. *See also* Patience
Equal Employment Opportunity Law (EEOL), 86, 103–04, 161

Fallows, Deborah, 37, 74, 139
Fallows, James, 39
Faludi, Susan, 154
Family, importance of, 33–34,
 50, 67, 111
Farkas, Jennifer Burkard,
 19–20
Feinstein, Diane, 81
Feminism in Japan, 31, 93,
 95–96, 98–104, 105,
 154–55, 158
Feminism in United States, 32,
 96, 97, 99–100, 140, 154
Flynn, Elizabeth Gurley, 97
Freed, Anne O., 63
Freedom
 of choice, 25–26, 121–29
 of Japanese women, 36–37,
 40, 61, 63
 in United States, 2, 25–26,
 120, 121, 129, 131, 148,
 151, 153
Friedan, Betty, 75, 154
Fukuzawa, Yukichi, 95, 96

"Gentlemen's Agreement" of
 1907, 11
Goldman, Emma, 98, 99
Great Civilized Learning for
 Women, 96
Great Japan Women's Organiza-
 tion, 102
Group, importance of. See Con-
 formity, Harmony, Hierar-
 chy, Social pressure,
 Teamwork

Hane, Mikiso, 157
Harmony, 24, 27, 32, 33, 152,
 154–55
Hartman, Heidi, 154
Hattori, Yoshihiro, 17
Hendry, Joy, 31–32
Hierarchy, 4, 19–20, 23, 26,
 32–33, 36, 74, 90, 151
Hiratsuka, Haruko ("Raicho"), 99

Homogeneous society. See Con-
 formity
Housewives, American, 32, 35,
 37
Housewives, Japanese, 31–40
 duties of, 32, 35, 81, 128–29,
 138–39
 power/control, 33, 35–36, 42
 self-perception, 32, 33–35,
 138
 status, 31–32, 33, 37–38, 39
Howe, Julia Ward, 99
Husband-wife relationships,
 41–48. See also Communi-
 cation: between spouses

Ichikawa, Fusae, 69, 102
Ie, 65–66, 67
Individuality, 22, 26, 33, 106,
 124–25, 131, 133–35,
 138–39, 142, 143, 147,
 148, 151–52
Inner selves, 41–42, 148, 153.
 See also tatemae/honne
"Integrated"/"general" career
 paths, 86–88
International schools, 23–25
Internment, 14
Issei. See Early immigrants
Itō, Noe, 99
Iwao, Sumiko, 32, 42, 142–43

Japan Times, 46, 60, 131
Japanese people, American
 views of, 14–15, 17–18,
 104
Jones, Mary Harris "Mother," 97
Juku (cram school), 57, 80, 134

Kageyama, Hideko, 98–99
Kaneko, Masaomi, 93
Kanno, Sugako, 99
Kato, Shizue (Ishimoto), 98, 102
Kichida, Toshiko, 98–99
Kikumura, Akemi, 12
Kitamura, Harue, 105, 161

Koch, Elenore A., 35–36, 38, 48, 49, 75, 77, 80, 87–88, 92
Kotoku, Shūsui, 98–99
Kyōiku mama, 57

Lam, Alice, 85
Language
 men's/women's, 90–92
 problems on return, 22–23, 24
 problems in United States, 12, 19
 at work, 89–92
Lanham, Betty B., 33
Late marriage, 42, 78
Lebra, Takie Sugiyama, 45, 61, 153
Life span, 46
Life stages, 59–61
Lindsley, Evangeline, 11–14, 101
Living conditions in Japan, 105, 115–19, 123–24, 129
Living conditions in United States, 3, 4, 5, 18–19, 22, 111, 115–16, 118–20, 129
Lowe, Matthew, 131–32

"M" curve, 74
"Madame Butterfly," 1, 2
Makihara, Kumiko, 90
Managers, female. *See* Employment, female, in Japan; Employment, female, in United States; "Integrated"/"general" career paths
Manjiro/Mung, John, 9–10
Marra, Robert J., 61
Mazakon ("mother complex"), 48
Meiji period, 9–11, 66, 98–99
Mitsui, Mariko, 161
Mockrish, Robert, 23–26
Moga ("modern girl"), 100, 103
"Momism," 48
Mori, Arinori, 96

Mothers, American, 53, 54–55, 137–40, 142
Mothers, Japanese, 49–57
 duties of, 50–53, 138–39, 140–41
 government support of, 54–55, 67, 79
 importance of, 50, 53, 55, 67
 inspiration for daughters, 64–65
 power/control, 49
 self-esteem, 49, 53, 57
 working mothers, 79–81, 84
Mukai, Chiaki, 105
Muramoto, Kumiko, 44
Murata, Ryōhei, 17
Murphy, R. Taggart, 154

Naishoku, 81
Nakane, Chie, 88
Natsume, Sōseki, 146
New York Times, 18
Newsweek, 61, 104
Nineteen-eighties, 84, 103–04
Nomura Securities Company, 75

"Office Ladies" (OLs), 60, 72, 75, 77–78, 86–87, 158
Ogata, Sadako, 106
Owada, Masako, 23, 86
Oyama, Sutematsu, 10–11
Ozawa, Ichiro, 106, 154

Patience, 33, 111, 141–43, 152–53. *See also* Endurance
Peace Preservation Law of 1887, 98
Perot, Ross, 49
Philip, Leila, 60–61
Politics in Japan, 91, 102, 105, 161–63. *See also* Feminism in Japan
Politics in United States, 162. *See also* Feminism in United States

Power/control, 32, 33, 35–36, 40, 42, 49, 60, 105, 143, 153
"hidden," 105
in historical times, 65–66
prewar years, 63
Pragmatism, 37, 42–43, 44, 46, 56, 81, 111, 153–54
Problems of sojourners, 17–27
children's education, 20–21, 114
customs, 19
fears, 17–18
language, 12, 19, 20
on return to Japan, 22–26
transportation, 18–19
Public self. *See tatemae/honne*

Rauch, Jonathan, 146, 148
Recreation, 45, 77, 127, 131
Religion and spirituality, 112, 113, 121, 124, 142, 145
Repass, Mary Eva, 20
Responsibility, 31, 32, 47, 49, 53, 60, 63, 67, 120, 128–29, 140–41, 151, 153. *See also* Mothers: duties of; Housewives, Japanese: duties of
Roland, Alan, 31, 151, 152
Rosemond, John, 52

Samurai, 66, 67, 98
Sanger, Margaret, 98, 102
Sekirankai (Red Wave Society), 100
Self-perception
American women, 33–34, 35, 138
Japanese women, 34–35, 38, 49, 53, 138, 153
Sex roles, 25–26, 32, 33–34, 36, 38, 47, 49, 105, 153. *See also* Housewives, Mothers, Self-perception
Sexual Harassment, 92–93

Sharp, Robert L., 60
Similarities of Japanese and Americans, 145–50
Situational ethics, 42
Sladek, Carol, 83
Social pressure, 39–40, 41, 53, 121–23, 126–27, 153. *See also* Choice, Conformity, Freedom
Social problems of United States, 2, 17, 119–20
Socialism, 97–98, 99
Sōgōshoku/ippan. See "Integrated"/"general" career paths
Soto/uchi (outside/inside), 41–42
Spirituality. *See* Religion and spirituality
Stanton, Elizabeth Cady, 99
Stone, Lucy, 99
Strength, Japanese definition of, 143
Strength of Japanese women, 2, 12, 26
of married women, 60
of older women, 60–61
in prewar years, 63–64
of young women, 59–60
Structure of society. *See* Hierarchy
Students, 3, 10, 112–13, 123, 124, 125, 146, 147

Taishō period, 66–67, 100–01
Takahashi, Kisako, 105, 159
Tanizaki, Juni'ichiro, 59
Tannen, Deborah, 89
Tanshin funin, 46
Tatemae/honne, 41–42, 152
Tea ceremony, 35
Teamwork, 141
"Third culture kids," 23–25
"Three highs," 42
"Three obediences," 42
Tokugawa period, 67
Trager, James, 38

HIGHLINE COLLEGE LIBRARY

Ueno, Chizuko, 66

Virginia Slims Survey of 1990, 43

Wa, 24
Wall Street Journal, 104

Wells, Wesley, 18
White, Merry, 22, 52
World War II, 63–64, 67, 101–02
Wylie, Philip, 48

Yotsuya, Nobuko, 91